MUSLIM
WOMEN
ARE
EVERYTHING

MUSLIM WOMEN
ARE
EVERYTHING

Stereotype-Shattering Stories of Courage, Inspiration, and Adventure

SEEMA YASMIN

Illustrations by **FAHMIDA AZIM**

WITHDRAWN

HARPER
DESIGN

An Imprint of HarperCollinsPublishers

HarperCollins books may be purchased for educational, business, or sales promotional use.
For information please email the Special Markets Department at SPsales@harpercollins.com.

Published in 2020 by
Harper Design
An Imprint of HarperCollins*Publishers*
195 Broadway
New York, NY 10007
Tel: (212) 207-7000
Fax: (855) 746-6023
harperdesign@harpercollins.com
www.hc.com

Distributed throughout the world by
HarperCollins Publishers
195 Broadway
New York, NY 10007

ISBN: 978-0-06-294703-1
Library of Congress Control Number: 2019060190

Design by Najeebah Al-Ghadban

Printed in Canada

First Printing, 2020

For Yasmin Halima—mother of dreams and me,
the bravest, wittiest, most creative woman I know

CONTENTS

INTRODUCTION ✦ 1

MUSLIM WOMEN ROCK ✦ 5
MUSLIM WOMEN WRITE ✦ 21
MUSLIM WOMEN DRIVE ✦ 39
Mipsterz ✦ 49
MUSLIM WOMEN GET POLITICAL ✦ 51
Muslim Women Play Bingo ✦ 64
MUSLIM WOMEN LAUGH ✦ 67
MUSLIM WOMEN DANCE ✦ 85
MUSLIM WOMEN MAKE NOISE ✦ 95
Things We Wear ✦ 112
MUSLIM WOMEN BRING HOME THE GOLD ✦ 115
Generation M ✦ 133
MUSLIM WOMEN MAKE HISTORY ✦ 135
Haloodies ✦ 147
MUSLIM WOMEN EXPERIMENT ✦ 149
MUSLIM WOMEN MEAN BUSINESS ✦ 167

GRATITUDE ✦ 182

INTRODUCTION

I HAVE WANTED to write this book since I was fourteen, the year I finally understood that Muslim women are everything. I had felt it even earlier, born as I was to a Muslim woman who cooked and cleaned and surreptitiously read books, who taught me how to read Arabic and dance to Motown jams, a woman who raised me alone even though a man was in the house. When I was still young, she left that man to go to university, an act that required an incredible amount of courage and was such a rarity in our Indian Muslim community in 1980s England that she was cast out by our family and chastised by the women for having the gall to divorce a bad situation. Muslim women are complicated.

After that, I was raised on and off by my aunt, a veiled woman who tagged a sixth daily prayer onto the mandatory five, who woke in the dead of night to chant holy salutations and went to work in a factory early in the morning, but not before oiling my hair, weaving it into tight braids, and preparing an elaborate meal for me and her three children. She would come home with smears of industrial oil along the sides of her fingers, ears still ringing, forever damaged by the oscillations of factory equipment. She would perform wudhu, heat up dinner, and fix broken things: cabinets, sofa legs, sewing machines. Then she would teach us how to fold samosas and fry okra, how to strip the walls of paint and mix wallpaper glue in big buckets, so we could make pretty the house she had bought alone. Muslim women are polymaths.

It was in my aunt's living room that I made the decision to wear hijab. I was twelve and reaching the apex of my devoutness. I never missed a prayer. I sometimes fasted even when it wasn't Ramadan. I turned my head and said astagfirullah when frothy beer commercials interrupted an episode of *Cheers*. I wore a hijab to bed so that if I died in the night, I could still enter heaven. I begged my mum, unsuccessfully, to take me out of secular school and let me attend an Islamic one. Just as I was making sense of my Muslimness, solidifying the rules of engagement with my faith and ringing up countless celestial points with my near-constant dhikr, my Muslim world got turned upside down. At fourteen, I left the Muslim community that had raised me in the middle of England and went to live with my mum in London. I thought I had arrived in Hades.

For the first time, I met Muslim women from outside of my community, Muslim women who messed up my neat and tidy definitions of "Muslim" and "woman." There were Muslim

women who loved women, Muslim women who prayed in mosques and not in their homes, Muslim women who dressed like men. I repented for all of them. I met Muslim women who weren't sure if they were Muslim, who said things like "exploring" and "figuring it out." There were women who were "culturally Muslim" or "of Islamic heritage," Muslim women who were Isma'ili and Ahmadi and "not sure" to my stunned Sunni Hanafi self. I talked to Muslim women who ran businesses and Muslim women who owned dogs, Muslim women who said forests full of trees—not mosques—were their sacred spaces. They disrupted and diversified my perspective and showed that Muslim women are not a monolith. Muslim women are Everything.

I have wanted to write this book since I was fourteen, but I began writing this book when I was thirty-four. Frustrated with the narrative surrounding Muslim women—one that, even when it purports to celebrate us, is surprised that we can do things: *Wow! Look at this Muslim woman run a marathon! Wow! This one is riding a bike!*—I fired off a fed-up tweet:

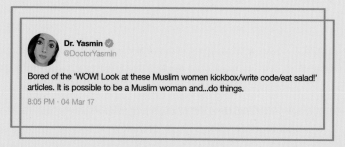

The tweet became a prose poem, which was published in a newspaper. I had rejected the invitation to turn it into an essay, not wanting to read, let alone write, another *We bleed just like you, weep just like you, let me prove my humanity to you* article. The prose poem was titled "Yes, Muslim Women Do Things," and it featured Muslim women doing incredible things. With illustrations by artist-extraordinaire Fahmida Azim, "Yes, Muslim Women Do Things" showed Muslim women reading books and taking naps. It talked of Muslim women performing open-heart surgery, rolling a cigarette, cursing a broken nail, digging salad out from between their teeth. Revolutionary.

"Yes, Muslim Women Do Things" struck a chord. I don't know if it was the eyebrow piercing on the Black khimar-wearing Muslimah's face or that the Muslim woman reading

a book was wearing hijab, but readers responded passionately and in droves. Some loved it, others hated it, but it was clear that there are still many people who believe Muslim women are One Thing; that we should be This and say That. (It was probably the furious trolling of the haters that landed us lots of attention and this book deal. Jazakallah khair.) Personal opinions aside, it's hard to ignore the facts: There are 1.8 billion Muslims on the planet in 2020 and, growing at a rate surpassing any other religion, we are estimated to number 3 billion by 2050. Soon, one in four humans will be Muslim, and half of them will identify as Muslim women. And Muslim women, with our higher education and employment rates compared to Muslim men, are leading the charge when it comes to the progression of our Ummah.

Three billion Muslims won't all look the same or sound the same or practice our versions of Islam in the same way. The 1.8 billion of us here now reach across entire spectra of ethnicities and denominations, languages and sexualities. From my mother's flat in the East End of London to my aunt's pious household in the center of England, we live differently, worship differently, dream differently.

I dreamed small dreams before I turned fourteen. I buried fantasies and limited my belief in all the things that Muslim women can be, because even though I was raised by complicated, brilliant Muslim women, all I saw around me—from the mosque committee to the school board to the houses of Parliament—it was men who ran (and ruined) things. Men told us that women must be subordinate and stay small and quiet. But that year, as I met Muslim women who made me uncomfortable and curious, my ideas of what we could be—what *I* could be—expanded to fill a universe.

The Muslim women celebrated in this book do everything: fly to space, start multimillion-dollar businesses, get fired from their jobs, jump over hurdles, bake cakes, take naps, wake up late, and do it over again. There are many more phenomenal Muslim women—surfers, prison abolitionists, and boxers among them—who didn't make it into this book. There are too many brilliant Muslim women for one volume.

This book, borne of frustration and ignited by a tweet, is a celebration of the sisterhood, of women questioning and redefining what it means to be Muslim and a woman. Fueled by our sisters' successes, saying mashallah to their tenacity, we are shedding other people's narrow definitions of success, of piety—of us. Muslim women are everything, and beginning here, the narrative is catching up.

MUSLIM WOMEN ROCK

THERE ARE as many interpretations of Islam's views on music—*Is it sinful? Does it enhance prayer and deepen a spiritual practice?*—as there are interpretations of a lyric. Music has long been part of the worshipper's rhythm: Sufism's devotional chanting, the percussing of the traditional daff hand drum, and a capella nasheeds are just some of the ways Muslims weave beats and quarter notes into our lives. But Muslim women also front heavy metal bands in burqas, zip Mohawks over hijabs, and pen melodies while studying in law school. We rock it onstage, in the DJ booth, in our bedrooms. Whether we are shredding electric guitars, beating drums, or plucking harp strings, Muslim women are humming the theme song to a revolution and writing the soundtracks to our own lives.

SONGS OF DEFIANCE

SZA, United States

BEFORE SHE BEGAN writing songs for Rihanna, Beyoncé, and Nicki Minaj, before she was partying backstage at Coachella, SZA (pronounced *sizza*) was a teenage Black girl growing up in Maplewood, New Jersey, singing and writing her way through the awkwardness of adolescence. Born Solána Imani Rowe in St. Louis, Missouri, to a Christian, Pan-Africanist mother and an Orthodox Sunni Muslim father, SZA attended church service one week, and went to mosque the next. Her father was a former member of the Black Panther Party, and his interpretation of Islam meant there was to be no skin on show, no watching television, no listening to the radio. SZA's interpretation of modest dressing was a wardrobe of baggy clothes that doubled as a way to hide what she felt was an overweight figure.

Her father had narrow beliefs about how women should move through the world, but one thing he did encourage SZA to pursue was her "little hobby," referring to her love of singing and songwriting. SZA sang to entertain her brother and his friends as an act of defiance, a way to combat the limitations placed upon her as well as face her insecurities.

Music was a journey to self-discovery and a way to process what it meant to be an outsider—always an outsider. In St. Louis, where she was born, and in Maplewood, where she was raised, SZA felt isolated and like the odd one out. In both cities, her uniqueness was not embraced, and she felt like an outcast. SZA was the only Black girl in school and the only Black girl in her Girl Scout troop. She felt like the token Black girl everywhere.

So she started writing songs, scribbling lyrics about her most private feelings. When she began to share her music, SZA found that people were nodding their heads in appreciation of the bass line *and* the themes she was exploring. What had felt like very personal issues and private dilemmas were universal pains about loneliness and life on the margins. Despite their apparent differences, SZA's fans were finding their own experiences reflected in her songs. Music became a form of connection as well as catharsis. Her songs, which contained her deeply personal thoughts, held the power to connect disparate people and diverse experiences.

SZA created her stage name using the Supreme Alphabet, a system developed by the Five-Percent Nation, also known as the Nation of Gods and Earths, a movement founded in the 1960s by Clarence 13X, a Black American who broke away from the Nation of Islam. Five-Percenters use the Supreme Alphabet to find deeper meanings in texts, including within the movement's central text, *Supreme 120 Lessons*. SZA's name is an acronym where the S stands for "Sovereign," Z for "Zigzag," and A for "Allah."

SZA wore hijab while she attended Muslim prep school but decided later that the head covering wasn't for her. As her relationship to her faith evolved, so did her relationship to her body, and she began to replace her baggy clothes with a new personal style.

Her style and musical talent were noticed by producer and rapper Terrence "Punch" Henderson in 2012 when she was in her early twenties. Henderson signed her to Top Dawg Entertainment, where SZA joined a roster of stars including Kendrick Lamar and Schoolboy Q. It was a solid start for the young singer, but then the momentum slowed. SZA was promised a debut album in 2015, but the year came and went and there was no record to show for it. She had already penned a song, "Consideration," for Rihanna's hit album *Anti*, as well as the track "Feeling Myself" for Beyoncé and Nicki Minaj. Frustrated by the lack of her own platform, SZA vowed to leave music behind. "I actually quit," she tweeted in October 2016. "@iamstillpunch [Henderson] can release my album if he ever feels like it. Y'all be blessed."

When her debut studio album, *CTRL*, was released the next summer, it came as a surprise to many people—including SZA. She was still choosing between the more than 150 songs she had recorded, selecting this one, deciding whether to include another, when her record company took her hard drive from her and took control. Ironic, given the album is about her realization that neither she nor anybody has full control over anything.

Two singles from *CTRL* charted in the top 40 of the Billboard Hot 100 and were certified platinum by the Recording Industry Association of America in 2017. But that didn't mean her family was happy. SZA's mother, who is featured on the album in spoken word interludes, was not impressed with her daughter baring her emotions; she doesn't talk about the album, not even with SZA, fearing her daughter leaves herself open to attack by exposing her innermost feelings.

Sharing our truths comes at a cost, it seems. There is liberation in radical honesty, in baring the ugly, the sad, the joyful. And then there is the fear of hurting those who presume silence is protection, who want to guard us from cultures and people who don't want us to speak openly about our relationship with Islam, our bodies and each other. Speaking up can put us in full possession of our experiences and desires—and in conflict. So we walk a line between transparency as freedom and muteness as defense.

In a photo spread for *Coveteur*, SZA sits in a mustard velvet armchair, her legs in lilac Versace flares crossed as she peers at you through the smoky lenses of vintage sunglasses. Her wardrobe vacillates from '90s sportswear to high fashion, styles as multifarious as her thoughts on faith and art. The woman who quit music and came back with a hit album reminds us we are not always in control and we are not static beings. We evolve, we unfold, we pair Adidas slides with haute couture, and we change our minds as often as we damn please.

"WHEN SHE BEGAN TO SHARE
HER MUSIC, SZA FOUND THAT PEOPLE
WERE NODDING THEIR HEADS IN
APPRECIATION OF THE BASS LINE *AND* THE
THEMES SHE WAS EXPLORING."

I AM PUNK

Tesnim Sayar, Denmark

THERE IS NO REASON we can't be all the things—even supposedly conflicting things—at once. Devout *and* potty-mouthed, ambitious *and* lazy. Despite persistent attempts to oppress and confine Muslim women and gender-nonconforming Muslims to narrow archetypes, we do it all. We rock hijabs *and* hoodies, burqas *and* tattoos. Tesnim Sayar, a Danish woman of Turkish descent, zips and unzips a plastic Mohawk over her hijab. Some days the Mohawk is black, some days it is bright red. In a photo widely shared and reposted on Tumblr, Tesnim pairs a red tartan skirt with tartan trousers and a black sweatshirt, loops of metal chains hanging from silver safety pins on her headscarf. In another image, a thick black belt heavy with studs is wrapped around her waist.

Tesnim describes a punk as a person opposed to oppression. "I'm tired of people's generalizations and stereotypes about Muslim girls," she told Danish newspaper *Dagbladet Information* in 2010. "Therefore, I am punk."

She began wearing hijab at eight and rivet bracelets at twelve. Finding ways to weave her religious expression with her artistic self led her to shop for goth jewelry in stores in Odense, the Danish city where she was born and raised. But finding fashion that truly represented her meant eventually learning how to make garments herself. Goth stores sold clothes that were too revealing for Tesnim. The alternatives were overly conservative. She decided to take matters into her own hands, so she enrolled in Design School Kolding in Denmark to study fashion. Now, a self-declared "hijabista," a Muslim fashionista, she sells her designs on Etsy, the artsy online marketplace.

She's not the only Muslim goth-punk—the 2003 novel *The Taqwacores* by Michael Muhammad Knight brought this underground subculture to the forefront. It told the story of punk rocker Muslims who prayed salaat on empty pizza boxes and combined drugs, sex, and worship. Named for a combination of the words *taqwa*—meaning "God consciousness" in Arabic—and *hardcore*, the novel represented hope for some Muslims who saw themselves in the fictitious characters. By 2007, dozens of real-life Taqwacore bands had formed in the United States. Five of the bands toured the northeast together

in a green school bus emblazoned with the word TAQWA. By 2009, a documentary film called *Taqwacore: The Birth of Punk Islam* was launched, and the next year, a film version of the book was released. The novel has become a manifesto for disillusioned Muslims.

Tesnim's love of goth-punk culture emerged before Taqwacore, but her belief of being true to self, regardless of what is expected, is the same. "My message is also that one should refrain from thinking that Muslim girls are sitting at home and are boring," she said to the *Dagbladet Information* newspaper. "I do not think Islam is oppressive, but I am against blindly living by traditions . . . The more you know, the more free you become."

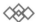

"TESNIM DESCRIBES A PUNK AS A PERSON OPPOSED TO OPPRESSION. 'I'M TIRED OF PEOPLE'S GENERALIZATIONS AND STEREOTYPES ABOUT MUSLIM GIRLS.'"

GUITARS AND NIQABS

Gisele Marie Rocha, Brazil

GISELE MARIE ROCHA shreds the electric guitar and people's expectations. In a niqab and burqa, Gisele plugs a Gibson Flying V electric guitar into an amp and begins to play. The black guitar with pink polka dots is accented by her shoes, also black with pink polka dots, and a flick of black eyeliner. After fronting her brother's band for four years, Gisele launched her own group in 2016. Eden Seed quickly emerged as one of Brazil's top thrash metal bands, combining Brazilian influences with heavy metal.

Gisele began wearing hijab and burqa after she converted to Islam a few months after her father's death in 2009. Born into a German Catholic family in São Paulo, Brazil, it was her father who introduced her to Islam through stories of the scientists and scholars who rose to fame during Islam's expansion in the seventh century. Her father wasn't Muslim—nor was anyone in Gisele's family—but the stories her father shared made a lasting impression on her. It was when he died that she began reading the Qur'an and began the path to conversion.

Gisele wore hijab after she converted, but when a Muslim friend in São Paulo said she feared wearing a niqab and burqa in public, Gisele agreed to wear the face and body covering with her, an act of solidarity for her friend. The pair went to cafes, shops, and gigs in traditional Muslim garb, and Gisele discovered that she liked moving through the world that way.

There is no burqa ban in Brazil, but Gisele is a minority in a country where only around 200,000 people—less than 1 percent of the population—practice Islam, according to Harvard University's Religious Literacy Project. Islam arrived in Brazil with enslaved Africans in the sixteenth century, while others in the country converted to Islam as they encountered Muslims from Yoruba, Hausa, and Malinke tribes. Early Muslims in Brazil were restricted from fully practicing their faith. Records show that slave owners didn't allow Muslims to pray and punished enslaved people for reading and teaching Arabic. Today, most Muslims in Brazil are from the Middle East, with some converts, such as Gisele and her friend. She says many Brazilians associate the burqa with oppressed

"I'M A GREAT BELIEVER OF INDIVIDUALITY AND WEARING THE NIQAB IS A PERSONAL CHOICE. I'D NEVER IMPOSE IT ON ANYONE ELSE. ONE SHOULD BE FREE TO WEAR WHAT THEY WANT TO."

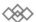

women who don't have a say in how they dress. She stresses that her decision is a personal one. "My Muslim friends and I are trying to combat this stereotype. I'm a great believer of individuality and wearing the niqab is a personal choice. I'd never impose it on anyone else. One should be free to wear what they want to," she said.

The focus on her appearance bores Gisele. She is treated like an "exotic tourist attraction" in São Paolo. The press attention is annoying, too. Gisele has played classical piano since she was eight and fronted her brother's heavy metal band, Spectrus, since 2012. There is so much more to talk about than her decision to cover her face and body—her musical influences, for a start. Gisele cites Jimi Hendrix and Lucia Jaco among the pioneers who drive her commitment to practice. Some days she spends six hours perfecting her guitar skills. Rocking it onstage, her head nodding as she shreds the guitar, Gisele has audiences transfixed. Some might fixate on the cloth that covers her, but that's not the point. Her blend of traditional Brazilian carnival themes and thrash metal merges with lyrics that challenge Brazil's political and social norms. The personal is political, and music weaves together the two strands. In an interview, she says: "There's a need to fight for women's rights. We need to have rights over our own bodies and how we choose to live our lives." But onstage, Gisele lets her fingers, metal strings, and amp do the talking.

A QUEEN WHO SLAYS

Yuna, Malaysia

WHEN YUNA FIRST MOVED to the United States at twenty-three, people asked the Malaysian singer-songwriter and law school graduate strange questions: *Are you educated? Can you drive? How come you don't wear black all the time?* Heavy with assumptions regarding what a Muslim woman from a Muslim-majority country should look and act like, the questions ignored that Malaysia is a multicultural and multi-confessional country, and that Yuna, like Muslim women everywhere, blends faith, culture, and art in her own life and practice.

"Take off your hijab and be you," she was told, as if headscarves block self-expression and jam the brain's gamma waves. "It's my personal choice," Yuna told *New York* magazine. "It's just kind of weird when people say 'take off your hijab and be you' because this is me, I'm being myself. I'm not oppressed. This is very liberating that I get to do this and be in the music industry. I like that I don't have to conform to the normal women-in-music-selling-sex-appeal thing." Among Malay Muslim women in the entertainment business, Yuna is one of few—she says "the first"—to cover her hair and body.

Famous enough to be part of the one-name club, Yuna, born Yunalis binti Mat Zara'ai, found her voice at age seven, singing in her family's home in the north of Malaysia. Her father's love of English music meant young Yuna jammed to '70s rock and bands from the '90s, including the Cardigans and Garbage. Yuna developed her own sound that's jazzy and acoustic, infused with pop and R&B. Some music critics liken her to Sade.

But any hopes of making it as a singer were dulled by rejection after rejection, despite her obvious vocal talents. Malaysian record labels called her "unpolished" or said wearing hijab would make it difficult to market her to a Western audience. Yuna applied to law school as an alternative career. But instead of stymieing her creativity, law school pushed her toward music. At nineteen, juggling classes on contract law and tort cases, Yuna taught herself to play guitar. Inspired by friends who were independent musicians in Malaysia's live music scene, she started to perform, first in jazz bars and neighborhood cafes, and then in a recording studio, lugging her guitar wherever she went. Things took

a serious turn in 2008 when, without the backing of a record company or manager, Yuna recorded her first album—in her bedroom. Her song "Deeper Conversation" made it into heavy rotation on Malaysian radio. Over the airwaves that summer, Yuna could be heard asking some questions of her own about hope, fear, and intimacy.

The song's success transformed Yuna's career trajectory. "That's when I started making money from my music," she told *Complex*. "That's when I thought that I could really focus on music full-time." Next came the move to the United States to sign with Fader Label and record with artists such as Pharrell and Usher—fellow members of the one-name club. Yuna's song "Crush," featuring Usher, peaked at number 3 on the US adult R&B Billboard Chart in 2016. The song appeared on her third studio album, *Chapters*, the album in which she "decided to let go of my insecurities" and "decided to be more blunt." Inspired by challenges in her personal life, Yuna let loose in the studio. "I really wanted to do something different; I was going through some rough times, and I wanted to be in a different space in life."

Album after album has launched Yuna to greater heights, earning her the respect of industry peers around the world. But success to Yuna looks like ownership of her art and lifting up others as she climbs. Soon after her first album release, Yuna launched Yuna Room Records and brought on board twenty-five-year-old Malaysian singer Nabilah Musa. The hijabi songstress who couldn't get signed and was forced to record her first album in her bedroom is now signing artists to her own label. She hopes to nurture a new generation of Malaysian artists who won't get sidelined by myopic record company executives, as she initially was.

At the 2019 Coachella Valley Music and Arts Festival in California, Yuna strutted past festivalgoers wearing trousers sewn from purple and pink songket, the traditional Malay brocade fabric hand-woven from silk and gold threads. Accessorized with combat boots, a FILA sweatshirt, and a black backpack, Yuna posed for Instagram photos, sparking a flurry of social media posts obsessing over her outfit and demonstrating, again, that Yuna's self-expression extends beyond music. She launched a clothing and lifestyle line and shop, November Culture, in 2014, following the success of her Malaysian boutique, IAMJETFUEL. The line featured the chic, urban style Yuna embodies, including her trademark turbans. "I really like the idea of modesty," she says in a magazine interview

where the focus, yet again, shifts from her music to her head covering. "By the time I got into music, I was already wearing the scarf all the time, and it's really personal to me, my Muslim beliefs, so I decided to keep it and find a way to work around it. I don't see it as a restriction or limitation—I can still be me and get into music and be an entertainer."

When she was forced to shut November Culture in 2018, citing a packed touring and recording schedule, she made an announcement on her blog, explaining: "A queen who slays was a queen who had failed." Beneath that caption, Yuna is photographed standing in a floor-length gown, black sequins shimmering along her silhouette, a gray turban tied in a knot above her eyebrows. After rejection and amid so-called failure, Yuna slays and slays again.

"IT'S JUST KIND OF WEIRD WHEN PEOPLE SAY 'TAKE OFF YOUR HIJAB AND BE YOU' BECAUSE THIS IS ME, I'M BEING MYSELF. I'M NOT OPPRESSED. THIS IS VERY LIBERATING THAT I GET TO DO THIS AND BE IN THE MUSIC INDUSTRY."

MUSLIM WOMEN WRITE

WE HAVE BEEN CENSORED, prosecuted, banned, and threatened, our books burned and our paragraphs outlawed—and still, we write. Muslim women write ourselves back into history, correcting history books authored by men who have relegated women to the footnotes or erased us altogether. Muslim women write so that we won't be forgotten; so another sister can find herself in our pages and know that her life— her fights and triumphs—are significant. We write so our stories can be passed on, like chromosomes, to those who will come after, knowing that words spark joy and books ignite revolutions. It's no wonder they have tried to stop us from writing: Sentences can change the world.

BREAK THE CHAINS

Ismat Chughtai, India

ISMAT CHUGHTAI refused to apologize. Standing in an Indian courtroom in 1946, she faced obscenity charges for a short story she had published four years earlier in an Urdu literary magazine. Her lawyers advised her to say sorry to the judge for writing this story so the charges would be dropped. Others even offered to go as far as to pay her legal fees if she would just take ownership for her supposed wrongdoing. But Ismat would not back down.

The summons arrived at 4:30 one afternoon in 1944. Policemen shouted at her front door as she warmed milk for her then two-month-old daughter, Seema. The summons read: *Ismat Chughtai vs The Crown.* Ismat laughed. "Good God, what complaint does the Exalted King have against me that he has filed the suit?" "It's no joke," said the policeman. But Ismat wasn't rattled by a court summons. "I've a great desire to see a prison house," she told the policeman, her daughter's milk bottle still in her hand. "Have you brought handcuffs?"

The inflammatory short story that threatened to put her in jail was titled "Lihaaf," or "The Quilt." It told the story of Begum Jan, a housewife married to a wealthy landlord who was often away from home pursuing relationships with men, and her maid, Rabbu, whose massages and cooking soothed and tantalized the neglected housewife. When Begum Jan's young niece comes to visit while her husband is away, she witnesses the sounds and movements emanating from beneath Begum Jan's lihaaf. Although the story touched on a taboo subject at the time, Ismat did not titillate with salacious details—instead, she left much of what happened in the story to the readers' imaginations.

Regardless, it was enough to land her in court. India in the 1940s, with its homophobic British laws, considered same-sex desire an illness and addiction, despite Indian mythology and religious texts brimming with homoerotic encounters between gender-shifting gods. Standing trial with Ismat was her dear friend and fellow Indian Muslim writer, Saadat Hasan Manto, master of the short story form and, like Ismat, a member of the Progressive Writer's Association, a band of authors from across the subcontinent who

"ISMAT'S WRITING PULLED BACK THE PURDAH ON THE LIVES OF INDIAN MUSLIM WOMEN AND GAVE VOICE TO THEIR FRUSTRATIONS AND DESIRES."

championed free speech. Manto faced obscenity charges for his short story "Bu." Although Manto believed in their freedom to write without the worry of censorship, not all of their peers were supportive of Ismat. An older author, in particular, felt she was trying to be lewd just to "compete with the men." Ismat disagreed: "I always endeavored to obtain higher marks than the boys in the class and often succeeded in that."

Education was always an important touchstone in Ismat's life. Her staunchest and earliest supporter was a man, her father, Mirza Quaseem Beg, who insisted Ismat receive an education, despite her mother and extended family arguing against the idea. "To educate a girl was worse than prostituting her," relatives told him. Ismat threatened to run away if she was denied proper schooling, but she understood that the oppression of girls and women was a systemic issue and didn't blame her parents for the challenges posed in trying to educate a young woman. "I felt pity, not anger, for my parents," Ismat wrote in her memoir, *Leaving Aligarh Once Again.* "They were trapped in their limited world." She went on to receive her bachelor's degree at Isabella Thoburn College in Lucknow, and a teaching degree at the nearby Aligarh Muslim University—she was the first Indian Muslim woman to obtain both a bachelor of arts degree and a bachelor's in education.

The ninth of ten children, she credited her second-eldest brother, Mirza Azim Beg, a well-known satirist and novelist, for her mastery of the short story. He encouraged his sister to read and translate stories from a young age. Ismat wrote an impassioned and

unconventional essay about him upon his death, and Manto, when he read the essay, remarked that he would be ready to die if his own sister would write such a eulogy. The piece was titled "Destined for Hell."

As Ismat progressed in her life and career, she made it clear that she had no intention of shrinking or toning down her words to make others comfortable. Having narrowly avoided an arranged marriage at fifteen, she established herself as a teacher and writer who was intent on carving out the life she designed.

Ismat's writing pulled back the purdah on the lives of Indian Muslim women and gave voice to their frustrations and desires. She questioned India's class and gender divisions and challenged the behaviors expected of Indian Muslim girls and women, refusing to play by the patriarchal book. As a girl, she befriended the children of the men and women who cleaned her family's bungalow. The washerman's daughter and the sweeper's son became her playmates, much to the chagrin of her family, who nicknamed her *chamari*, the word used to describe low-caste Indian women who performed menial labor. This dichotomy made its way into her short story "Vocation," where sex workers try to make friends with a judgmental high-caste woman. In "Marigold," a lower-caste woman falls deeply in love with a man from a higher caste. In "Lingering Fragrance," village girls are hired by royal families to sexually train young princes. Her stories reflected her personal experiences so closely that it was difficult to know where real life ended and where fiction began. She named characters after her family members and plotlines resembled her own ups and downs and lifelong struggle to dismantle class boundaries.

She wrote "Lihaaf" in only one night, and read it to her sister-in-law the next morning. "She didn't think it was vulgar though she recognized the characters portrayed in it," Ismat wrote in a memoir. Readers were often confused about her facts versus her fiction, but she wouldn't offer clarifications. Ismat reveled in ambiguity.

Before she married filmmaker Shahid Lateef, Ismat wrote him a warning letter describing herself as a troublesome woman. "Later on, you'll regret marrying me. I have been breaking chains all my life. I won't be bound in any chain now." Boundless, chainless, Ismat fought to tell her stories her way. The obscenity charge was eventually thrown out of court, but not before it established her legacy as a fearless force, an expert storyteller, and a champion of women's voices.

BOOKS ARE PEACEFUL WEAPONS

Mariama Bâ, Senegal

WHEN MARIAMA BÂ WAS BORN in Senegal's capital, Dakar, in the spring of 1929, the country was still under French colonial rule. Senegal had endured four hundred years of Portuguese, British, and Dutch colonial regimes, but as Mariama was born, it was inching its way toward independence. Over the next three decades, as Senegal found its voice and discovered its power, Mariama unearthed her own talents, developing an eye for observation and a gift for writing the stories of Senegalese women grappling with their own fight for freedom.

Born into an affluent Dakar family of Lebu descent, Mariama studied the Qur'an in madrasa and received a secular education in a colonial school. She attended secondary school until the age of fourteen, long past the time most girls were pulled out, their education cut short by parents who wanted them to cook, clean, and prepare to be wives. But Mariama's father wanted his daughter to read books and ask questions. He spoke to her in grammatically accurate French, now the official language of Senegal, as well as Wolof, another widely spoken language, and as he rose from the civil service to deputy mayor of Dakar, and eventually became Senegal's first minister of health, his dreams for his daughter grew bigger. But he had to fight to keep Mariama in school. Her mother had died when she was a young girl, and the role of maternal caregiver was assumed by her grandmother and her grandmother's co-wives, the three other women her grandfather had married. In their compound next to a mosque, Mariama's grandparents extolled traditional beliefs that were at odds with her father's progressive ones. Mariama pounded millet, ironed boubous, turned flour into couscous, and washed clothes. But her father continually pleaded with his parents to let the girl study. This tension in women's roles, the expectations of girls and the clash between faith and feminism, would be a key feature in many of the novels Mariama would write as an adult.

At the end of her schooling, a surprise exam result—the highest grade in all of Francophone West Africa—guaranteed Mariama entry to the prestigious École Normale, an exclusive teacher training college in Rufisque, a suburb of Dakar. But Mariama's father

"MARIAMA'S WRITING POKED AT LONG-STANDING TRADITIONS AND GAVE VOICE TO THE STORIES OF WOMEN, WHICH ARE TOO OFTEN CENSORED OR NOT TOLD AT ALL."

was away on business when the news arrived, so it fell to Mariama's schoolteacher to break the news to her grandparents and assume the role of pleader-in-chief. Mrs. Berthe Maubert, the schoolteacher who had insisted the talented but reluctant Mariama take the exam, sat down with the traditionalists in the Bâ household to explain the magnitude of Mariama's achievement and the importance of a higher education. "[She] had the lonely task of overcoming the resistance of my family who had had enough of all this 'coming and going on the road to nowhere,'" Mariama said.

Mariama graduated as a schoolteacher in 1947, taught for twelve years, and was appointed to the Regional Inspectorate of Education of Senegal. But teaching wasn't her only passion. She fought for the rights of Senegalese women and frequently held leadership positions in women's empowerment organizations. She married three times during her twenties and thirties, gave birth to nine children, and divorced three times, always of her own choosing. She divorced her third husband after twenty-five years of marriage, citing "opposing temperaments" and "two sets of roiling opinions." She singlehandedly raised nine children in a society that deemed women incapable of surviving without a man.

It was after her third divorce that the idea of a book emerged. Although she had already penned many newspaper articles and journal essays, some say she had not been planning

to write a book until her friend, the children's author Annette Mbaye d'Erneville, told a publisher that a manuscript from Mariama was on its way. Mariama had yet to write one word of any novel, but the pressure was on. She refused to let the editors down, or worse, give them a reason to see a woman fail. Inspired by the oral storytelling traditions of her community and the specifically West African tradition of the griot, or professional storyteller and historian who is given license to speak without censorship, Mariama began to write a story. She conjured a tale that took the form of a long letter, a conversation between two Senegalese women during transformative phases of their lives in 1960s postcolonial Senegal. Ramatoulaye, a retired schoolteacher, is recently widowed after a long marriage, and is writing to her friend Aissatou about grief, death, and life, during her observation of the Islamic tradition of iddat, the period of ritual mourning that lasts four lunar months and ten days after a spouse's death. Before her husband died from a heart attack, Ramatoulaye had been thinking of divorcing him after twenty-five years of marriage because he had taken a second wife, a friend of his daughter's. Aissatou, too, is wrestling with her own emotions after leaving Senegal for New York because her husband also took a second wife.

This debut novel, *Une si longue lettre*, translated into English as *So Long a Letter*, was published to critical acclaim and international fanfare in 1979 when Mariama was fifty years old. Considered to be partially autobiographical, the book won the first-ever Noma Award for African writers published in Africa. Mariama described her novel as "a cry from the heart of all women everywhere. It is first a cry from the heart of Senegalese women, because it talks from the heart of Senegalese women, women constrained by religion and other social constraints that wear them down. But it is also a cry that can symbolize the cry of women everywhere."

Mariama died from cancer two years after her first book was published. During her battle with the disease she continued to write, working on a second novel that was published after her death. *Un Chant Écarlate*, or *Scarlet Song* in English, tells the story of a Black Senegalese man who marries a white French woman. The couple navigates a 1960s Dakar in which interracial marriages, in the rare instances that they did occur, involved white European colonialists taking black Senegalese women as wives. *Scarlet Song* was published in 1986 and like *So Long a Letter*, was translated into more than a dozen languages.

The Senegalese schoolgirl who became a teacher, feminist activist, and world-renowned novelist captured the lives of Senegalese women exploring their identity, and their relationships to the institutions of marriage, religion, patriarchy, and each other. Mariama's writing poked at long-standing traditions and gave voice to the stories of women, which are too often censored or not told at all. *So Long a Letter* is considered one of the first feminist novels written by a West African woman. It inspired countless more women to pick up a pen and write.

Mariama described herself as a "modern Muslim woman," a woman who found her strength in words and stories. In an interview conducted just six months before her death at age fifty-two, she said: "We cannot go forward without culture, without saying what we believe, without communicating with others, without making people think about things. Books are a weapon. A peaceful weapon perhaps, but they are a weapon."

WRITE THE SCRIPT FOR YOUR LIFE

Fawzia Mirza, Canada

IF YOU PICKED A CAREER for the wrong reasons, Fawzia Mirza can relate. To please her parents, divert the pressure to marry, and play it safe, she went to law school and practiced law for three years before quitting at age twenty-nine to pursue her real passions: acting and writing.

Fawzia's family moved to the Midwestern United States from Canada when she was a teenager. She had done theater in high school, but it wasn't until her early professional years that she reconnected fully with art. Fawzia was a lawyer by day but took theater classes at night and spent her free time reading books on how to become an actor. She landed her first role playing the fairy Cobweb in *A Midsummer Night's Dream*, reciting all three of her lines as her brothers watched in the audience.

In 2006, her father suddenly and unexpectedly died during a family visit to Pakistan, and Fawzia dedicated months to performing the familial duties expected of a "good" daughter. But a change had been brewing in her, and she decided it was time to take action. While transitioning from the role of perfect Pakistani lawyer-daughter into the truest version of herself, Fawzia revealed two pieces of news to her recently widowed mother: She was embracing acting, and she was gay.

The news came almost as a surprise to herself, and it took some time to adjust to her new identity. In the summer of 2007, as she explored her queerness in Chicago's clubs and bars, she was often the lone brown Muslim woman in queer spaces. She didn't see anyone who looked like her, and she began to wonder if she would need to sacrifice parts of herself to exist in either Muslim spaces or queer ones.

This self-exploration found its way into the roles she was playing onstage. Fawzia soon realized that real power lay in writing her own lines, not letting white men dictate her dialogue and movements. "I started writing because I wanted to play characters who looked and lived like me. Instead of waiting for someone else to do it, I decided, I'll just change the narrative myself," she said. Her first short film posed the question: Can I be queer and Muslim at the same time?

Fawzia decided life should imitate art, and in writing both her characters and then her own life story, she rejected stereotypes in place of fully human, fully fleshed-out women who lived at the intersections of race, gender, immigration, and sexuality. Fawzia lived and plotted her own narrative arcs. "You just have to create your own identity and everyone's gonna have opinions on everything else and that noise will likely never go away, whether it's from queer people or from Muslim people or from brown people . . . Everyone has an opinion on who you are and you have to transcend the noise."

When she began to shop her projects, she found that studios were reluctant to produce queer Muslim stories written by a queer Muslim woman, so Fawzia assumed the role of producer, as well as writer and actor, and cofounded Yellow Wing Productions. Lesbian romances were reimagined as Bollywood epics in films like *Queen of My Dreams*. Multiple web series offered the freedom to play with characters such as Kam Kardashian, the long-lost lesbian sister of a celebrity family, and Ayesha Trump, the illegitimate Muslim daughter of the man who, at the time, was running for president of the United States. Fawzia's 2016 web series, *Her Story*, was nominated for an Emmy Award for Outstanding Short Form Comedy, and a year later, she premiered her first feature film at SXSW. In *Signature Move*, Fawzia plays Zaynab, a Pakistani lawyer who lives with her recently widowed mother and falls in love with Alma, a Mexican American bookstore owner who she meets while reading books and drinking whiskey at a bar. Starring veteran actress Shabana Azmi as Zaynab's mother, the film did something maddeningly unusual—it cast a queer brown Muslim woman as the protagonist, representation that Fawzia continues to introduce into her prolific writing for stage, television, and film.

Her first television script was for a 2019 episode of the CBS drama *The Red Line* and featured a gay South Asian Muslim man named Liam Bhatt. "There was no representation of positive straight Muslim characters at the time, much less positive queer Muslim representation," Fawzia told the *New York Times*. "So for me, writing was a way of creating some of that representation." Fawzia's writing gives Muslims space to be all of the things: lawyers and actors, daughters and lovers, queer and certain, straight and confused. Her writing rejects the very idea of *other* and *or* and lets us settle into the expansiveness that is our lives. Her writing busts open the margins.

REFUSE TO BE RESPECTABLE

Suhaiymah Manzoor-Khan, England

"**THIS WILL NOT** be a 'Muslims are like us' poem," Suhaiymah Manzoor-Khan said onstage at the 2017 Last Word Festival in England. Facing the audience, Suhaiymah was really in conversation with her own poems: the poem that wanted to be written—the one that explained her humanity, her good grades, her banter in line at the post office—and the poem she wanted to write, the poem that smelled like morning breath, scratched at the skin like raw honesty, the poem that bristled with discomfort. The twenty-two-year-old British Pakistani playwright, poet, and educator won second place in the spoken-word festival with "This Is Not a Humanising Poem," a performance that went viral when a video of Suhaiymah circulated on social media. It was watched and shared more than two million times and landed her on the websites of *Huffington Post*, *The Guardian*, and media outlets around the world.

Only three years earlier, she had been an anonymous blogger, writing about life as a Muslim woman in England on her website, *The Brown Hijabi*. One particular blog post found its way to the pages of a British newspaper: a post that expressed her anger about the burkini ban along the French Riviera in 2016. *The Independent* ran Suhaiymah's piece with the headline: "Dear white people of France: being forced to undress wasn't exactly the liberation I was longing for." She wrote the essay in a fit of rage and posted it to her blog anonymously. But on the newspaper's website, readers were able to respond directly. Hundreds of comments challenged and supported her analysis on the ban and the policing of Muslim women's bodies in places like France and Iran. Suddenly, she had a global platform—she was holding a microphone, owning her words, and taking up space.

Born in Bradford in the north of England and educated in state schools in Leeds, Suhaiymah defied the odds to study history at the University of Cambridge, where more than two-thirds of students are white and almost half are private-school educated. Strolling along its immaculate lawns, reading books in its 800-year-old libraries, and eating at the long wooden tables inside its halls, Suhaiymah's presence at Cambridge was a revolutionary act, one that carried with it a particular burden. "Rather than an 'I've made it'

feeling, accessing such a privileged place of education felt like a 'we've made it.' We carried the dreams of those before us on our backs," she wrote in an essay, part of a series reflecting on her experiences as a brown Muslim woman in an elite, white-dominated institution. Along with three other female students of color, Suhaiymah compiled the essays and poems into a book, *A Fly Girl's Guide to University: Being a Woman of Colour at Cambridge and Other Institutions of Power and Elitism.* Published in 2019, *A Fly Girl's Guide* was the book Suhaiymah wished she could have read before entering the hallowed halls of Queen's College, Cambridge, and offered advice on dealing with racist professors, entitled classmates, and the weight of expectations placed upon women of color. In one of the book's poems, "When They Find You Unpalatable and Abrasive, That Is When You're Doing It Right," she asks the reader to practice self-acceptance and self-forgiveness, to not apologize for existing, to not say sorry for being too brown or too black or too anything: "'Sorry.' But this time I say it to myself. 'Sorry' they tried to hold you down. 'Sorry' you believed they should . . . Do not be sorry to exist."

After Cambridge, Suhaiymah studied postcolonial studies at another elite institution, the School of African and Oriental Studies in London, where her master's thesis focused on the British surveillance state and its spotlight on Muslims, particularly those belonging to her own British Pakistani community. It is that community, the diaspora, the outsiders, that she writes for. The Muslim women who are vilified when they cover, and berated when they don't.

Muslims are often viewed as existing in a binary: victim *or* hero, moderate *or* extreme, acceptable *or* suspicious. Suhaiymah's writing vehemently rejects that dichotomy; her words burn binaries to the ground and repurpose the cinders into fresh ink with which she pens her own declarations. In Suhaiymah's poems, Muslims float across spectrums of gender, class, and political ideology. In her essays, Muslims fret over college applications and groceries, the aftermath of colonialism and the quotidian brutalities of a police state. But Muslim women *are* police officers. Muslim women *are* conservative. Muslim women *are* radical feminists and anarchists and poets and philosophers and are capable of being all these things at the same damn time.

At the end of "This Is Not a Humanising Poem," Suhaiymah asks herself a question: Does her refusal to conform, and her refusal to defend her faith in her writing, her speak-

ing, her penning her truths, make her radical? Muslim women are expected to defend Islam, explain their rituals, explain their dress, justify their existence—anything contrary to this is seen as a radical act. Suhaiymah's debut poetry collection, *Postcolonial Banter*, grapples with these dilemmas. Her writing uncages Muslim women from societal constructs, from imposed and unimaginative definitions of their faith. Suhaiymah refuses to be "respectable," to write the words that are expected of her: "I put my pen down. I will not let that poem force me to write it, because it is not the poem I want to write. It's the poem I've been reduced to. Reduced to proving my life is human because it is relatable. Valuable because it is recognizable . . . Because if you need me to prove my humanity, I'm not the one that's not human."

"IN SUHAIYMAH'S POEMS,
MUSLIMS FLOAT ACROSS SPECTRUMS OF
GENDER, CLASS, AND POLITICAL
IDEOLOGY. IN HER ESSAYS, MUSLIMS FRET
OVER COLLEGE APPLICATIONS
AND GROCERIES, THE AFTERMATH
OF COLONIALISM AND THE QUOTIDIAN
BRUTALITIES OF A POLICE STATE."

MUSLIM WOMEN DRIVE

BANNED FROM DRIVING, forbidden from racing sports cars—Muslim women drive to the grocery store, up the corporate ladder, through checkpoints, across unchartered lands. In Mustangs and Honda Civics, on bicycles and yachts, Muslim women drive movements and history, hurtling down roads paved by our sisters.

When Saudi Arabia lifted its ban on women drivers in 2018, seventy thousand women applied for driver's licenses before the year was over. But restrictions remain for women race car drivers in some parts of the world. Outracing their male competitors, these women threaten the masculinity of their slower peers and are forced to fight off the track for their right to race on it.

Military checkpoints and male bureaucrats won't stop the women celebrated in this chapter. Fingers wrapped around steering wheels, feet mashing gas pedals to the ground, Muslim women are signaling that a revolution has begun. The rev of the engine is our freedom song.

SPEED SISTERS

Marah Zahalka, Noor Daoud, and Mona Ennab, Palestine

WE DON'T COUNT our strength in horsepower, we count our strength in sisters, like Marah Zahalka, Noor Daoud, and Mona Ennab, cramming ponytails into helmets, cracking knuckles, and whispering bismillah, racing through the West Bank, leaving men in the dust. The sisterhood is strong—and fast. Marah, Noor, and Mona are the fastest women in Palestine. Team members in Speed Sisters, they're the first women's racing team in the Arab world. They transform old street cars into racing machines, buff wax onto hoods, and paint racer-girl stripes onto acrylic nails before demolishing the competition.

In their West Bank homes, the women motion for mothers and cousins to come out from the kitchen and hand them rocks, corralling them to chip away at the metal frames of an old black Volkswagen, a yellow BMW, and a red Peugeot. Smashing and sawing pieces off the chassis, they remove deadweight to lighten the women's load.

Marah first stole her father's car when she was eleven. Sitting in the driver's seat, too short to see where she was headed, she rounded up the neighborhood kids and told them, "Push!" "I couldn't get it into second gear so I drove through the whole neighborhood in first," she laughs in a documentary named after the team, directed by Amber Fares. By nineteen, Marah had been crowned racing champion of Palestine. Now, she ties a black-and-white kafiyyeh around her neck, grins behind black sunglasses, and does donuts on a makeshift racetrack. A tree-shaped air freshener thrashes from the rearview mirror of her souped-up, canary-yellow BMW. No helmet, no limits; just shades and a smile.

A refugee on her own land, Marah races for her refugee camp in Jenin, home to fourteen thousand Palestinians displaced by violence and conflict. "Let's go, Jenin! Let's go!" the crowd chants on race day as Marah pulls down her visor and slams the car door shut. Her engine growls. "I feel a responsibility to represent Jenin," she says. "People really count on me to get a high rank."

The Speed Sisters regularly place first, second, and third in national competitions, the male racers trailing behind. The women race as a team but they are also competing

against one another for the title of fastest woman in Palestine. Speed Sister Betty Saadeh, a non-Muslim Palestinian Latina (third illustration down on page 40), vies for first place. Betty often comes in second to Marah, but still managed to land a rare and coveted endorsement deal with Peugeot. "I'm beautiful and attractive. I'm media savvy. I'm a brand."

The strength of the sisterhood is tested in each race. A referee pits the women against one another, tightening the rules to disqualify one woman and loosening rules to let another stay in the race. In one race, a referee banned Marah from racing in Jordan, forbidding her from representing Palestine abroad—a once-in-a-year opportunity. Team captain Maysoon Jayyusi advocated for fairness, but the one-man adjudication team refused to budge.

On the track, the Sisters are under pressure to win each and every race, to constantly prove their place and worth. There is the added hurdle of made-up rules designed to curb their passion and punish a woman's audacity to dream. Off track, the women drive against the pressure to conform. Maysoon's grandmother tells her the neighbors chide her boyish granddaughter. "They say, 'You should tell your granddaughters to cover their hair!'" her grandmother says. Marah's grandfather mentions that he would not have let her race to begin with. "We wish she'd study to become a doctor and work in a respectable field," he says. But Marah's father counters: "She is already respected. Even in London, she is the Champion of Palestine!"

Muslim women drive against misogyny and expectations. Some days, finding the strength to keep driving demands a toughness that seems out of reach. "The smell of tear gas reminds me of my childhood," says Maysoon, winding up the car windows as she drives through an Israeli checkpoint. She ducks behind the steering wheel at the *tatt tatt tatt* sound of automatic gunfire. Ambulances screech nearby.

Maysoon's car journey would take fifteen minutes without the checkpoint. Instead, it takes her an hour to get where she is going. One of Palestine's fastest women is stuck behind soldiers, her shirt pulled over her nose to block the stench of burning. It was this frustration of being stuck at checkpoints, of long hours in a car going nowhere, that inspired Maysoon to race cars. Tired of moving slowly, having her movements dictated by men with guns, she found freedom on the racetrack.

Her Speed Sister, Noor, feels the same. But for Noor, racing is also part of her swagger. "Driving cars, drifting, it's so me," she says, referring to the motorsport where drivers

steer a car sideways through a turn and take control of the car's movement even as the tires lose traction. "It's me, like my hair," says Noor, grabbing fistfuls of thick, black curls. "What I wear, my style, my personality." On a live television interview with a newscaster in Dubai, Noor laughs when the anchor says: "I just want to point out the irony that a car rally could easily happen in any country except Palestine because every few minutes you face a military checkpoint."

Muslim women turn up the volume, mash the pedal to the floor, and drive to purge the rage. Gassed up on our grandmothers' prayers, petrol drunk, we careen around every barrier and dream of never stopping.

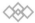

"MUSLIM WOMEN TURN UP THE
VOLUME, MASH THE PEDAL TO THE FLOOR,
AND DRIVE TO PURGE THE
RAGE. GASSED UP ON OUR GRANDMOTHERS'
PRAYERS, PETROL DRUNK, WE
CAREEN AROUND EVERY BARRIER AND
DREAM OF NEVER STOPPING."

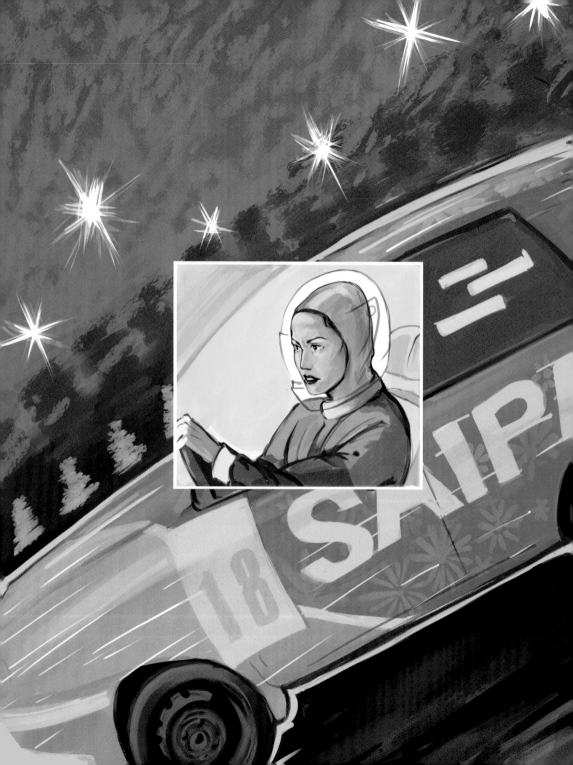

DIFFERENT ROAD, SAME STORY

Laleh Seddigh, Iran

LALEH SEDDIGH, the flame-haired, red-lipped racing driver, is one of Iran's top athletes, and fights the same battle as Palestine's Speed Sisters. Laleh is consistently dubbed "Little Schumacher" or "the female Schumacher." But Laleh is not the female version of any man—she is the one and only Laleh Seddigh. A race car driver with a doctorate in engineering, she had a girlhood penchant for sneaking late-night drives in her dad's car and a love affair with the stink of gasoline. Laleh drives because: "I have to move whatever is moveable in the world."

Laleh is celebrated, Laleh is a winner. In 2008, she was forbidden from racing men by the Iranian Motorcycle and Automobile Racing Federation. But Muslim women drive through loopholes. Upset by the ruling, Laleh escalated the ruling to Iran's leader, the Ayatollah, and demanded a fatwah—a legal ruling made by a scholar—and returned home triumphant. But there was a stipulation: She could compete against men only if she dressed modestly. Laleh accepted the conditions, and eventually, so did the Federation. She rose to become champion of the 1600 GT class. Still, Iran's state-run television refused to broadcast Laleh on the winner's podium with trophies in hand.

Three years later, she was banned from racing altogether. Officials visited Laleh's garage and accused her of tampering with her car, but Laleh knew that she was really just being targeted for daring to compete in the men-only, fastest racing category known as Free Class. "They don't really want a good competitor who is a female, and they prefer to compete against other men. And that's the problem, that's the only problem. They think it's something against the traditional rules of Iran."

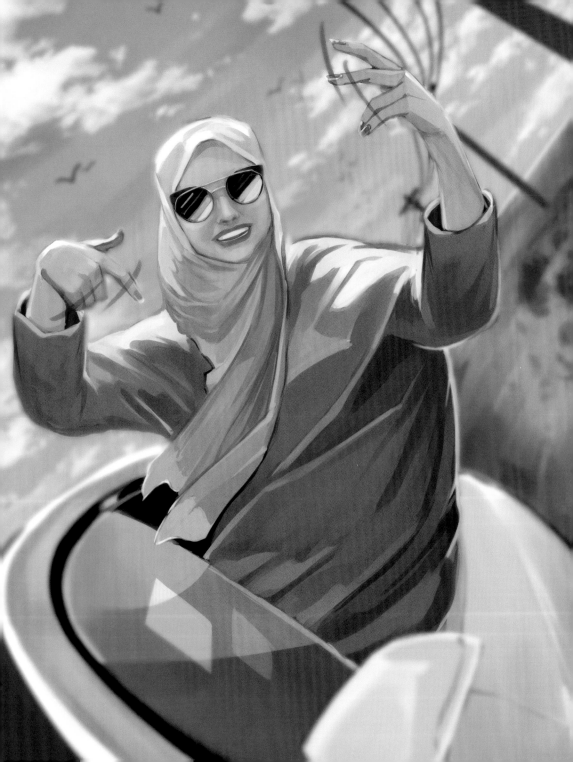

RAPPIN' AND REPPIN' IN SAUDI

Leesa A., Saudi Arabia

MUSLIM WOMEN DRIVE to celebrate, to proclaim victories that are decades in the making. In the summer of 2018, when Saudi Arabia lifted its ban on women driving, Leesa A, a young woman from Riyadh, made a rap video that went viral, spreading on social media from Jeddah to Michigan, and landing her on the pages of *Rolling Stone*. Spittin' bars at the helm of a silver Hyundai, wearing a white hijab, spinning wheelies in Arabian sands, and throwing hands up to the camera, Leesa A rides a victory lap and declares:

> *The steering wheel in my hands*
> *I smash the pedal under my foot*
> *I won't need anyone to drive me*
>
> *I'll help myself by myself*
> *I've got the driver's license ready with me*
> *So put the seat belt on the abaya*

Leesa's viral video was hashtagged "hajjat al-baqarah al-qrunaha," an Arab proverb that means "the cow has performed pilgrimage on its own horns," a phrase used to describe a task considered so difficult that it seems impossible.

The fight to drive began before Leesa A was born, when the Women to Drive Movement organized women to get behind the wheel and drive through Saudi Arabia's streets, a crime punishable by torture and imprisonment. In spite of this danger, dozens of women drove through the capital city, Riyadh, in 1990 to demand women have the right to drive cars outside of compounds and on Saudi's streets. Many of the women were arrested and forced to hand over their passports to authorities.

In 2007, Saudi writer and activist Wajeha al-Huwaider worked with a group of women to petition the king to lift the ban on women drivers. A video of Wajeha cruising down a Saudi highway on International Women's Day in 2008 was uploaded to YouTube and

"SPITTIN' BARS AT THE HELM OF A SILVER HYUNDAI, WEARING A WHITE HIJAB, SPINNING WHEELIES IN ARABIAN SANDS, AND THROWING HANDS UP TO THE CAMERA, LEESA A RIDES A VICTORY LAP . . ."

went viral. The video could have landed her in prison, but instead of being deterred by threats of punishment, Wajeha continued to fight. Inspired by the Arab Spring uprisings in 2010, Wajeha and fellow activist Manal al-Sharif amped up the Women to Drive Movement. But as they did, one Saudi woman, Shaima Jastania, was sentenced to ten lashes for driving a car in Jeddah.

Even as the ban on women drivers was lifted in June 2018, Saudi women were being punished for having the audacity to fight for their right to drive. The nation's ruler declared that women could now drive cars, while dozens of women activists who had fought for that very freedom were imprisoned. Many remain in detention months after the law was changed.

Leesa A's 2018 viral rap was a declaration of these women's sacrifices, and a celebration of a new freedom. For the sisters who didn't yet know how to drive, Leesa's rap was also instructional:

> *R is for going back*
> *D is for going seeda*
> *Watch out for every hadida!*

Muslim women drive to make progress. For the right to move freely, to dream big, to live where we want to live and love whom we choose to love. Muslim women drive to be more than a religion, more than a gender, more than the "first Muslim" anything.

MIPSTERZ

"MIPSTERZ," a portmanteau of "Muslim" and "hipsters," was born out of an internet chat group and took the internet by storm in 2013. In a now-famous viral video set to the music of Jay Z's "Somewhere in America," biker girls, athletes, fashionista attorneys, and skater girls in high heels took control of their own narratives. They hopped over fences, shrugged shoulders to the bass line, slipped helmets over hijabs, and rode motorbikes through city streets. It quickly became the theme song, video, and website of a movement. Layla Shaikley, a former skater kid turned architect and entrepreneur, co-produced the video to amplify the artistic expressions and cultures of Muslims from across America while emphasizing that the term "mipster" was an ironic one, meant to serve as a "perpetual critique of oneself and of society."

Two-thirds of the 3.5 million Muslims in America are the first-generation kids of immigrant parents who migrated from seventy-seven countries, according to a 2011 study by the Pew Research Center. That means America's Muslims are a multilingual mix of cultures and identities, not a monolith represented by the few talking heads who make it to cable TV news panels.

The mipsterz music video created a storm. Watched more than 100,000 times in two days, it was loved by those who saw themselves represented for the first time, and loathed by those who felt excluded. Shaikley had reignited a conversation about the diversity of Muslims in America and the desire to tell our own varied and diverse stories.

The mixed reactions delighted Shaikley, who believes being American means she can inhabit multiple identities at once. She lists a few of her own: skater, artist, architect, entrepreneur, techie, video producer, and faithful Muslim.

MUSLIM WOMEN GET POLITICAL

Running countries and running households, Muslim women are stepping up and taking control as architects of our lives and leaders of our communities. The women in this chapter are making waves as some of the first Muslim women politicians and heads of state in their countries. Having lived through bad governance and incompetent leadership—all the way from community boards to federal governments—Muslim women are through with having rules dictated to us. Brazen, imperfect, and energized, Muslim women are taking charge.

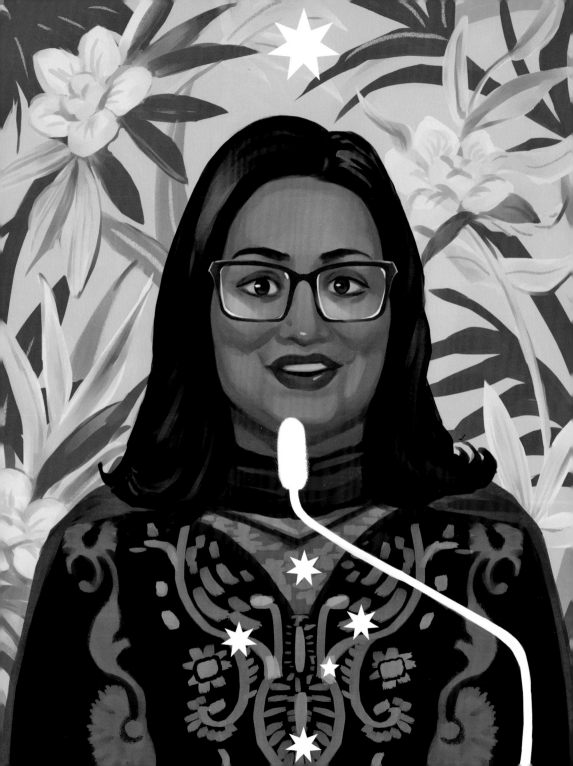

SHAKE THINGS UP

Mehreen Faruqi, Pakistan

IN HER FIRST SPEECH to Australia's Senate as a member of Parliament in 2018, fifty-five-year-old Pakistan-born Dr. Mehreen Faruqi let loose a firecracker tongue and told all the truths. Looking at the mostly white male senators assembled before her, Mehreen said: "Assalamu-alaikum. We are gathered here today on stolen land. I acknowledge the traditional custodians of this land, the Ngunnawal and Ngambri people, and pay my respects to their elders, past, present, and emerging. We must recognize that sovereignty was never ceded."

She recited poems by Pakistan's greatest poets, Allama Iqbal and Faiz Ahmad Faiz, in Urdu, and announced her "troublemaking streak." Australia's first Muslim woman senator—an engineer, professor, immigrant, and activist, and the first and only Muslim woman elected to any Australian parliament when she entered the New South Wales Legislative Council in 2013—had arrived. While news cameras broadcast Mehreen's speech live from inside the Senate, Mehreen listed her five-year track record as a politician during which she had been "shaking things up and shifting the agenda" on issues including drug reform, the decriminalization of abortion, LGBTQIA+ rights, and environmental protection. Standing before her new colleagues in a pink-and-black salwaar kameez, a dupatta draped around her neck, Mehreen reminded them how she had held to account the "weak-willed" politicians in her state of New South Wales. "I intend to do the same here."

Twenty-six years before that speech, Mehreen immigrated to Australia from Pakistan, arriving as a twenty-nine-year-old with a husband, one baby, and two suitcases. Having studied civil engineering in Pakistan, Mehreen completed a master's degree and then a PhD in environmental engineering at the University of New South Wales. Mehreen's husband, also a civil engineer, drove a taxi for a year when they first arrived in Sydney. "A familiar migrant story," Mehreen says. They raised their son and added a daughter to the family, joking that the kids might become engineers, too.

Mehreen comes from a family of engineers. Her father and father-in-law, two older brothers, and younger sister are engineers. Her father was a professor at Pakistan's

University of Technology and Engineering in Lahore, and growing up in their home on the university campus, Mehreen listened to her father say that engineers could do anything. But that didn't mean engineering was a certainty for her. Getting her bachelor's degree in civil engineering in Pakistan in 1988 "was probably less of a passion for engineering, more making a point about women in engineering," she told the *Sydney Morning Herald*. "There were hardly any women practicing civil engineering in Pakistan." In fact, there were none: Mehreen was the only woman out of the country's 2,000 civil engineers.

"AUSTRALIA'S FIRST MUSLIM WOMAN SENATOR—AN ENGINEER, PROFESSOR, IMMIGRANT, AND ACTIVIST, AND THE FIRST AND ONLY MUSLIM WOMAN ELECTED TO ANY AUSTRALIAN PARLIAMENT WHEN SHE ENTERED THE NEW SOUTH WALES LEGISLATIVE COUNCIL IN 2013—HAD ARRIVED."

Her 1,999 male counterparts were nice enough, but it wasn't only the blatant gender inequality that drove her out of Pakistan in 1992—it was the corruption she observed in Pakistani politics. Across departments, through the lowest and highest ranks, dishonesty and deception were pervasive.

Australia had its own problems, but it was the country of her childhood dreams: Mehreen's father had studied at the University of New South Wales in the 1950s on a scholarship, and had brought back to Pakistan fond memories and pretty photos.

Mehreen grew up in Lahore looking at pictures of the Sydney Harbour Bridge and thinking that Sydney was the most beautiful city in the world.

As a new resident of that city in the 1990s, Mehreen juggled raising an eighteen-month-old son with the workload of a graduate student, and she started to become involved in feminist and environmental activism. In 2004, four years after receiving her doctorate, she joined the Australian Greens, a political party that lists ecological sustainability, social justice, and grassroots democracy among its core values. The first election she won was in 2013 for a spot in the New South Wales Legislative Council—the win that made her the first and only Muslim woman in an Australian parliament. The hate mail began to arrive soon after. Mehreen continued to speak up and push for change, unfiltered and undeterred. She fought for the rights of gay people to marry and introduced the first bill to decriminalize abortion. In 2018, five years after her first political victory, the proud Muslim mother of two stepped up to a seat in the federal senate.

Mehreen's experiences as an immigrant, Muslim, woman, mother, and activist informed her speech in the summer of 2018. Hate crimes had surged in Australia. Politicians were fueling the flames of white supremacy. One week before Mehreen gave her first senate speech, a senator from Katter's Australian Party, a political party formed in 2011, called for Muslims to be banned from immigrating to Australia. Mehreen had something to say about that: "I'm a Muslim migrant woman, I'm heading to the Senate on Monday, and there's nothing Senator Fraser Anning can do about that." Once inside the Senate, Mehreen did not mince her words. She said some of Australia's politicians were "creating and fanning racial divisions."

Her position in politics has led to accusations that Mehreen is not "Australian enough" to serve the country. Mehreen's response? "But how can I be Australian enough? Do I need to point to my love of cricket? My career in the public service? My husband's role as major in the army reserves?" People of color in white-dominant societies are often forced to walk the lines of "enough." Not quite brown enough, never quite assimilated enough, to the point that we feel, well, like we can never be enough. Mehreen refuses to play that game. "Instead of being accepted because this is our home, we are asked to apologize for every action of someone who looks like us. We are subject to rules that white people never will be . . . for some, we will never be Australian enough."

Australia's first Muslim woman senator has been bombarded with hateful messages on social media, posts asking how a Muslim has "been let into Australian politics," letters asserting that women shouldn't be involved in national decision-making. "The reality is that my presence in the Senate is an affront for some," Mehreen said. "They are offended that people of color and Muslims have the audacity to not only exist, but to open our mouths and join the public debate." But Mehreen has turned the tables on the trolls and taken control of her story. She started a social media project called "Love Letters to Mehreen" in 2016, a public collection of, and responses to, her worst hate mail. The project offers reprieve to Mehreen and her staff who otherwise sift through the mail in quiet shock. Every few weeks, she picks a bigoted message and responds to it, with colorful memes and cartoons and "just a touch of sass." The response to these letters—such as "Dear Phark, If you are going to spend 30 seconds sending racist hate mail, spend an extra five running spellcheck"—has been overwhelming, and she's become something of a social media star. But it's not only faceless internet dudes who do the trolling. A recent video that Mehreen compiled of every way one senator mispronounced her name during a 2018 senate committee hearing, despite Mehreen gently correcting him each time, went viral. Feminist blogs and social media sites declared Mehreen "a destroyer of trolls," "a legend," and "an icon."

For this attitude, as well as for her tenacity, hopefulness, and hard work, Mehreen was awarded the feminist Edna Ryan Grand Stirrer award in 2017, particularly for her role in the decriminalization of abortion. She was named one of the one hundred most influential engineers in Australia, and for women in Pakistan, Australia, and around the world, she has won over hearts for being unapologetically, loudly, beautifully a "brown, Muslim, migrant, feminist woman."

VICTORIOUS VISIONARY

Ilhan Omar, Somalia

WHEN SHE WAS EIGHT YEARS OLD, Ilhan Omar heard men with big guns shoot at the front door of her family's home in Somalia's capital, Mogadishu. It was 1991; the country's president, dictator Siad Barre, had been ousted and Mogadishu was under siege by rival militias. War had begun.

Ilhan was the youngest of seven children, and all her siblings, her father, and grandfather survived the shooting that night. (Her mother had died when she was younger.) But a few days after the attack, knowing that conflict would worsen, the family split into smaller groups and fled the country in search of safety. Ilhan and her father flew to Kenya—her grandfather, Babu Abukar, had served as Somalia's National Marine Transport Director and knew people in Nairobi. Father and daughter arrived in an unfamiliar city and lived with strangers until they felt like they had outstayed their welcome. With nowhere else to go, they arrived at the sprawling Utanga refugee camp outside Mombasa, a newly built camp spread over four miles and littered with beige tents and huts. They found shelter inside a tent and hunkered down to avoid the kidnappings that were so common and the mosquitoes that spread infection.

Utanga refugee camp was their home for four years. When Ilhan turned twelve, a Lutheran church sponsored her family to go to the United States. Ilhan arrived in Arlington, Virginia, in possession of two English phrases: "Hello" and "Shut up." Her classmates yanked at her hijab, stuck chewing gum to it, and bombarded her with questions like, "Do you have hair? Do you have a pet monkey? Does it feel good to wear shoes for the first time?"

Every day, the girl who had survived armed militias and a refugee camp was reminded that she was different. "This is the first time I realized the stigma that I carried as an immigrant and a refugee, and a Muslim person who was visibly Muslim, with a headscarf," she told *The New Yorker*. "And that my blackness was a source of tension." But as the kids bullied her, Ilhan remembered her grandfather telling her as a child: "Everything is temporary." His words gave her courage.

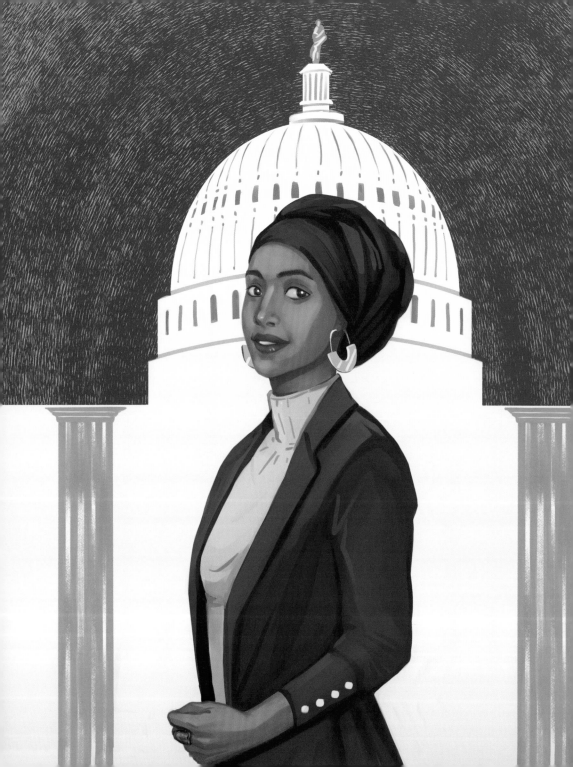

A few years later, the family moved away from Virginia to the Cedar-Riverside neighborhood of Minneapolis, also known as Little Mogadishu, home to America's largest Somali community. There was less hijab-yanking and slightly fewer slurs, but still many refugee-child experiences to come—including serving as translator to her grandfather at a meeting of the Minnesota Democratic–Farmer–Labor Party, a center-left political group. It was 1997, Ilhan was a teenager, and this was her first foray into politics. Walking into the precinct caucus at a local community center, she was met with bright lights, banners, and plenty of conversation. Ilhan was hooked. "There was something intoxicating about it for me," she told *City Paper*. "There was this platform. People could put forth ideas that could contribute." Party leaders spotted the spark in the young woman's eye, and when Ilhan asked them for advice on how to become politically involved, they were eager to give her guidance on a future in electoral politics. Ilhan studied political science at North Dakota State University and came home to Minneapolis, where she worked as campaign manager for a Minneapolis City Council candidate. When he won, Ilhan was promoted to policy advisor.

As the young woman with bright lipstick and even brighter turbans emerged as a promising future candidate of the DFL party, she endured disinformation campaigns from misogynists within her community, and from conservative bloggers outside of it. At one point, Ilhan was physically attacked and suffered a cut lip and concussion.

Women in Ilhan's community who supported her said, "Ilhan, I want to vote for you, but my husband won't allow it." Still, she persisted. "Political power in Somalia rests with men," she said. "I think there is a feeling by some people in politics and in my own community that the woman can think she's leading all that she wants, have a semblance of influence, but the ultimate voice rests with the man . . . I am not one who subscribes to that belief." Knowing the attacks could worsen, Ilhan forged ahead, running for election in 2016 to represent Minnesotans in the state's House of Representatives. She won, beating a twenty-two-term, forty-four-year incumbent. The victory stunned her. "I nearly collapsed when I saw the numbers," she said.

Just days before the election, Donald Trump had visited Minnesota and told a local crowd: "Here in Minnesota, you've seen firsthand the problems caused with faulty refugee vetting, with large numbers of Somali refugees coming into your state without your knowledge, without your support or approval, and with some of them joining ISIS and spreading

"COUNT THE FIRSTS: ILHAN IS THE FIRST SOMALI AMERICAN EVER TO SERVE IN CONGRESS, THE FIRST BLACK WOMAN TO REPRESENT MINNESOTA IN CONGRESS, THE FIRST MUSLIM WOMAN TO SERVE IN CONGRESS, AND THE FIRST PERSON TO WEAR HIJAB IN THAT CHAMBER. "

their extremist views. You've suffered enough in Minnesota." Ilhan had won in the face of that hate speech. And it was only the beginning of her political rise.

Next, she ran for an even bigger platform: to represent Minnesota's 5th Congressional District at a national level. On the campaign trail, Ilhan talked about her three kids, her college debt, and the realities of life as a Muslim Somali American woman. With middle-class white voters and Somali Americans, she shared her story while focusing on their daily struggles. Two years later, in 2018, she was elected to serve in the US House of Representatives. Count the firsts: Ilhan is the first Somali American ever to serve in Congress, the first Black woman to represent Minnesota in Congress, the first Muslim woman to serve in Congress, and the first person to wear hijab in that chamber. (The same day Ilhan took office, the House voted to allow hijab and other religious headwear inside Congress, essentially lifting a ban that dated back to 1837.)

Muslim women shake things up. Personal victories, though, are international triumphs that reverberate through the Ummah. We are tired of firsts, done with tokenism, and ready for our sisters to rise with us. "I talk all the time about the eight-year-old me and all the eight-year-olds who are living in their camps," Ilhan said to *The Guardian*. "I hope my victory gives them hope." Her victory gives us more than hope, it gives us vision. Yet, even without the story of a Somali refugee propelled from refugee tents to the gilded halls of America's Congress, Ilhan still managed to soar and manifest a goal. "I would have loved to have heard a story like mine," she said. "I could have used it as an inspiration to get by."

LAYERS UPON LAYERS

Rashida Tlaib, United States

ILHAN OMAR didn't step into Congress alone in January 2019; another Muslim woman took office alongside her. Rashida Tlaib, representative for Michigan's 13th Congressional District, was the other first Muslim woman in Congress. Rashida boasted yet another first: She was first in her family to graduate from high school. The daughter of Palestinian immigrants, a single mother of two boys, and the oldest of fourteen children, Rashida had blasted through other people's expectations of what it meant to be a Palestinian American woman. And at every step, she was taking all of her heritage with her, proudly representing Michigan and Palestine. At her congressional swearing-in ceremony, Rashida wore a floor-length, long-sleeved black and red thobe, the quintessentially Palestinian dress, which is typically hand-embroidered by women from Palestinian villages. The stitching and styles vary across Palestine, but thobes with lavish designs are worn to mark special occasions, such as puberty, motherhood, and now entry of a Palestinian American woman into the United States Congress.

Rashida posted a close-up of her thobe on Instagram. Intricate flowers, trees, and geometric designs popped in turquoise, blue, and yellow threads. Everything about Rashida's decision was deliberate, down to the stitch. Cypress trees around the waist of her dress symbolized resilience; embroidery stretching to the ends of her sleeves demonstrated that this was a garment made for a celebratory occasion. She had inherited the thobe from her mother, Fatima Elabed, who had left a small farming village in the West Bank and arrived in America at twenty. With only an eighth-grade education, Fatima worked as a dressmaker to feed her family. As a young girl growing up in Detroit, Rashida had watched as her mother sat on the floor next to a lamp stitching tatreez, the traditional hand-stitching used to embroider thobes, a skill passed down from mothers to daughters. After Rashida appeared in a thobe at her swearing-in ceremony, the thobe trend spread across social media, inspiring a hashtag, #tweetyourthobe. Women across the world posed wearing their own thobes and traditional dress.

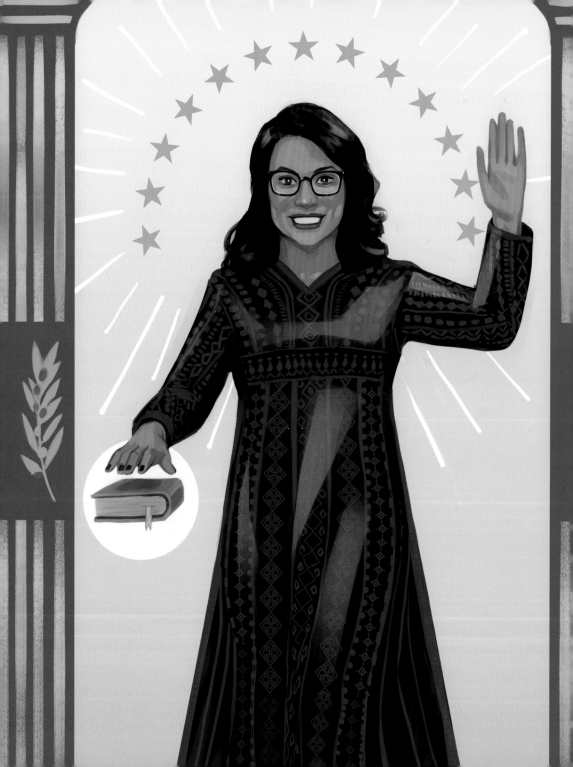

Thobes have a political connection, too. After the nakba in 1948, when more than 700,000 Palestinian Arabs were forced out or fled from their homes during the Palestine war, thobes became a symbol of Palestinian identity and land rights. Rashida was channeling that fight against injustice in her work for the people she represents in Detroit and its neighboring areas. "Throughout my career in public service, the residents I have had the privilege of fighting for have embraced who I am, especially my Palestinian roots," she wrote in *Elle* magazine. "This is what I want to bring to the United States Congress, an unapologetic display of the fabric of the people in this country."

Rashida trained as a lawyer and served for six years as a state representative in Michigan before running for national office. On the campaign trail, flanked by reporters, Rashida pulled her hair into a ponytail and took her son to work. While she answered calls in the back seat of a car, seven-year-old Yousif squeezed between his mother and the backrest. At a Detroit television news station, Rashida played with Yousif in front of the not-yet-rolling cameras. She was minutes from being interviewed live on-air. Motherhood is as important to Rashida as serving her constituents and standing up for the oppressed. "Mom" was the first role she mentioned in a CNN interview the day of her national victory: "I'm going to be a mom, a Muslimah, a Palestinian, an Arab and so many of these other layers," she said.

But carrying so many firsts can also feel like a burden. "I knew the win would be uplifting so many people with me. It feels like a lot of weight on me to give them a voice." Rashida carried villages of women with her as she crossed the stage in Washington, DC, to swear the Congressional Oath on the Qur'an. Grateful for the triumph, the possibility to inform national policies, and to be in control, she said, "Sometimes I say, 'Thank her,' because my Allah is She."

MUSLIM WOMEN PLAY BINGO

IF YOU'RE A MUSLIM woman playing this special version of bingo, you've probably heard it all before. The *Why can't you drink wine? It must be so hard to be you* to the *Oh. My. God. So-and-so said you drink wine. You will burn in hell, sister. But I'll pray for you.*

　　If you're not a Muslim woman, welcome to our world. From the Islamophobic to the absurd—and often an asinine mixture of the two—Muslim women endure ignorant comments the world over. Sometimes they come from our own, sometimes they come from non-Muslims who harbor misconceptions about what it means to be a Muslim woman and assume we are oppressed and overheated beneath our chadors and hijabs, or else wildly rebellious and confusing (to them) when we twerk in booty shorts on the dance floor.

DO YOU HAVE TO WEAR IT?	BUT BACON IS DELICIOUS!	PANEL OF MUSLIM SPEAKERS WITH ZERO BLACK WOMEN	OMG I LOVE RUMI!	MOOZ-LAMB
YOUR EYES ARE SO BEAUTIFUL	WHY DO YOU CALL HIJAB "KHIMAR"?	ARE YOU ALLOWED TO . . . ?	BUT BEING GAY IS HARAM	NINJA
YOU LOOK EXOTIC	FORCED MARRIAGE	ASTAGFIRULLAH!	IS IT THE SAME AS KOSHER?	OPPRESSION
CAN YOU GO SWIMMING?	WHY CAN'T YOU SPEAK ARABIC?	IS IT HOT UNDER THERE?	MASHALLAH, SISTER	MODERATE MUSLIM
POOR THING	GO ON, DRINK SOME WINE— NO ONE IS LOOKING	HOW MANY WIVES DOES YOUR HUSBAND HAVE?	YOU DON'T SEEM MUSLIM	ISIS BRIDE

MUSLIM WOMEN LAUGH

MUSLIM WOMEN are commanding audiences, cracking jokes, and forging careers as stand-up comics and entertainers. From viral videos to one-woman shows, we deploy humor to enlighten and illuminate, but more importantly, we use humor to experience joy. We laugh till we cry, till we pee, till we forget. We belly laugh to give ourselves the strength to smash the patriarchy, find a date, do the laundry, write a book, get out of bed. In a world that tries to laugh at us, Muslim women have turned the tables and weaponized an art form: Humor is our not-so-secret weapon, joy is our punchline.

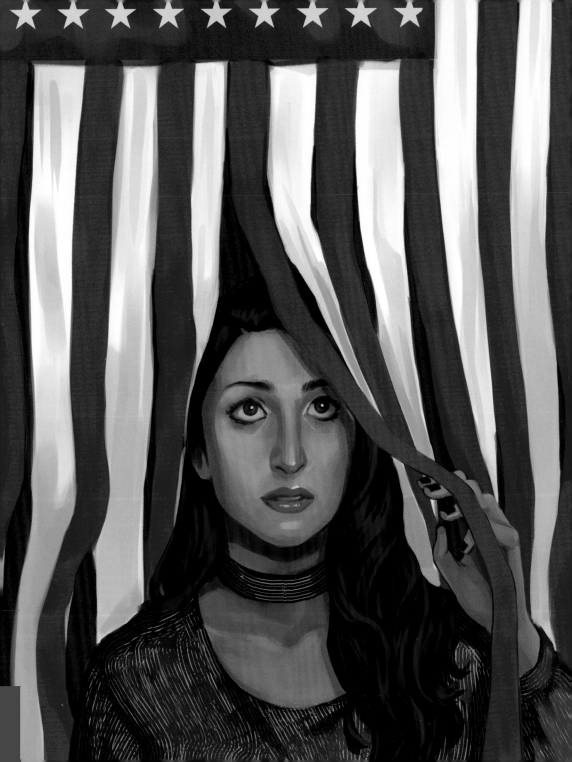

LUCKY CHARMS! LUCKY CHARMS!

Zahra Noorbakhsh, United States

IRANIAN AMERICAN COMEDIAN, writer, and actor Zahra Noorbakhsh discovered how to weaponize laughter at age five. In the cereal aisle of a California grocery store, Zahra put her body between her mother and the angry white man threatening her, and shielded them using humor in the form of a silly dance and song—"Lucky Charms! Lucky Charms!"— with a cereal box. Zahra's Lucky Charms jig worked: the angry man's face softened, his pointed finger fell to the side of his body. He smiled at Zahra's antics and backed away from mother and child, shaking his head as he walked down the aisle, laughing. Five-year-old Zahra had deployed comic relief and deescalated what could have been a violent encounter. It was a lesson she would carry with her for life.

Zahra's parents emigrated from Iran and settled in northern California, where she was born in 1980. They lived through the Iran Hostage Crisis and the Gulf War, two events that deepened the rift between Iran and the United States and contributed to widespread Islamophobia. Zahra's mother wore hijab at the time, which made her an easy target—she soon became accustomed to the middle fingers, the angry red faces, the intimidation, to clutching her children to her as neighbors threatened to ram their cars into them. Zahra, meanwhile, had discovered a way to play child peacekeeper. On the playground, in the grocery store, at home, she deployed humor: her secret weapon for dissolving fear and cracking through tension.

At home, Zahra used humor to sweeten her father, impersonating his parenting style, the way he frowned when she didn't get an A+ in algebra, emulating him by saying: "Our people invented algebra!" How he shook his head when she did get an A+, chiding her for choosing what must have been an easy class.

Laughter became therapy, even medicine. When she was nineteen years old, Zahra's fifteen-year-old brother complained of hip pain and a fever. Their mother, an X-ray technician, knew something was badly wrong and took him to the doctor. But the doctor, noting her hijab and dismissing her as an overly worried woman from a culture that dotes on boys, disregarded the symptoms. It turned out to be cancer.

Her mother's persistence paid off and Zahra's brother was correctly diagnosed, eventually, and treated. He lived. But when the September 11, 2001 attacks happened, the family's multimillion-dollar lawsuit against the negligent doctor—a lawsuit by an Iranian Muslim family against a white American—was dropped by their lawyer. "Listen, 9/11 just happened," a different lawyer told Zahra's family. "There's no judge or jury that is going to side with you with that thing around your head against an American doctor."

We laugh, we cry. We laugh to keep from crying.

Zahra's Persian dad jokes were a hit at the University of California, Berkeley, where she studied theater and performance studies. She staged a show for the Iranian Student Cultural Organization, basked beneath the warm glow of the spotlight, and beamed as the audience, including her father, lapped it up.

But were Zahra's audiences laughing with her or at her? Either way, humor transformed tension into a lightness, into: *Oh, maybe you people are just like us after all.* Her routines were about life as a self-described "pork-eating, alcohol-drinking, premarital sex–having, bisexual feminist Iranian Shi'a Muslim," exploring dilemmas like moving in with her white boyfriend—dilemmas that, she hoped, would help audience members connect on common ground.

But it didn't go as planned. As they trickled out of the auditorium, audience members would thank Zahra and say she must be "one of the good Muslims," the kind they could tolerate. Her act hadn't made them more empathetic to Muslims. Instead, she was singled out as an exception, an outlier from a tribe of villains.

Zahra began to be characterized as the "good Muslim" or "moderate Muslim" (whatever that is supposed to mean), and requests to perform this role kept rolling in from eager TV producers, especially in the post-9/11 era. Where humor had once been a way to dissipate tension, Zahra now wanted to do the opposite: She wanted to use humor to shine a light on the tension, to prod the pain points, not pretend to make them disappear. The *Look, we are just like you* comedy routines were out, and Zahra started a podcast in 2015 with activist and storyteller Tanzila Ahmed called "Good Muslim, Bad Muslim" that poked fun at the false dichotomy.

"To the Muslim community, we are 'bad' Muslims," the pair say on their website. "So so bad." But "to non-Muslims, we are 'good'—we don't drink, we don't do drugs . . . we

are social justice activists and community leaders. We are successful, published, accomplished." In 2016, President Obama invited the pair to record the "Good Muslim, Bad Muslim" podcast in the White House.

Zahra's latest comedy activism involves taking on more than Islamophobia and xenophobia—she is taking on the comedy industry itself, challenging its patriarchal structure and narrow emphasis on a club circuit dominated by men. A funny, complicated, nuanced take on the joys of being a Muslim needs a longer set, more face time with the audience, and a new development model. In 2018, Zahra was named one of Pop Culture Collaborative's Senior Fellows on Comedy for Social Change. She's using that opportunity to take comedy out of bars and into theaters, where she is staging a one-woman show that tells her story exactly the way she wants to tell it: truth with a dose of comic relief.

"WHERE HUMOR HAD ONCE BEEN
A WAY TO DISSIPATE TENSION, ZAHRA NOW
WANTED TO DO THE OPPOSITE:
SHE WANTED TO USE HUMOR TO SHINE A
LIGHT ON THE TENSION, TO PROD
THE PAIN POINTS, NOT PRETEND TO MAKE
THEM DISAPPEAR."

UNDERCOVER COMEDIAN

Sakdiyah Ma'ruf, Java

SAKDIYAH MA'RUF jokes that her destiny as a comedian was cemented in second grade when she came in second in a comedy competition—out of three contestants. But that childhood dream was blocked by her community, who insisted women marry, have children, and stay far away from microphones and stages. Sakdiyah grew up in a Yemeni-Arab enclave on the northeastern outskirts of Pekalongan in Central Java, attended a religious school known as a madrasa and a government school, which led her to Yogyakarta's Gadjah Mada University, where she earned her first degree in English and her master's degree in American Studies. She was the first student from a madrasa to receive a degree at the elite university, but her experience in the academy was not what she had anticipated. Sakdiyah had been looking forward to a liberal and progressive academic environment where she could explore the boundaries of faith and artistic expression. Instead, she found herself in classes with Indonesian Muslims who had grown up with more autonomy than she but were choosing to adopt a strict interpretation of Islam and conservative values.

Sakdiyah's love affair with telling jokes began in 2009 when she discovered a DVD of American comedian Robin Williams performing on Broadway. She watched him sweat and curse and pace up and down the stage and knew immediately that she wanted to do the same.

She booked her first comedy gigs when she was twenty-seven and discovered the art form mandated honesty. Making audiences laugh meant not only confronting her own life choices and flaws, but embracing them. In her early comedy sketches, Sakdiyah, who is an Indonesian of Arab descent, played a maid and poked fun at society's limited expectations of women. Gradually, she broadened her repertoire and explored a range of roles and issues, from domestic violence and religious extremism to Muslim fashionistas.

Inspired by American comedians Margaret Cho and Ellen DeGeneres, as well as rock star Sheryl Crow, Sakdiyah kept writing and refining her routines. She also trained as a translator, an occupation whose constant travel helped conceal her gigs in comedy clubs

"COMEDY WAS SAKDIYAH'S WAY TO PROCESS
THE PAIN, BUILD COMMUNITY
WITH OTHER SURVIVORS, AND SPEAK ABOUT
AN EXPERIENCE SHE SHARED WITH
MANY GIRLS AND WOMEN. SHE REFUSED TO
PIPE DOWN OR CENSOR HER MATERIAL."

from her conservative family. When she did eventually tell her family about her secret life as a comic, they asked her never to talk about being Muslim onstage. Television producers were equally restrictive. They told Sakdiyah to censor her jokes for fear of offending viewers. She refused. In two languages, Bahasa Indonesia and English, she poked fun at Indonesian culture, conservative imams, and conservative attitudes to critical issues, such as domestic violence. Sakdiyah witnessed violence in her home as a child and was intimidated by and sometimes terrified of her father. "There are many men in my community who still think they live in the desert," she said. "That they need to hit women to relieve their stress from fighting the infidels." Comedy was Sakdiyah's way to process the pain, build community with other survivors, and speak about an experience she shared with many girls and women. She refused to pipe down or censor her material.

It was a national televised comedy contest that elevated Sakdiyah to prominence in 2011. Although she reached the finals, some complained that her jokes about Islam and extremism were no laughing matter and that her content needed to be modified. Sakdiyah rejected their demands. "In comedy, there's no such thing as tragedy or pain, just our

ability to see irony in everything," she said. "Good comedy makes you laugh. Great comedy makes you cry." She followed her television success with the co-creation of a stand-up show called *Perempuan Berhak*, which featured a lineup of women comedians. The show was performed in 2014 and 2017, and in between, Sakdiyah married a man of her choosing, someone from outside of her community. She considered the feat a personal victory against her upbringing, and in her comedy routines she describes her wedding as "having dinner with hundreds of people so I could have sex."

Soon after the wedding, when she was pregnant with her daughter, the BBC honored Sakdiyah's tenacity and humor by including her in the 2018 BBC's 100 Women List, citing her as Indonesia's first Muslim woman stand-up comic. Sakdiyah hopes she is the first of many Indonesian women comedians, Muslim and non-Muslim, hijabi and non-hijabi. Uncensored and unedited, confronting the joys, hard truths, and absurdities of being women, especially Muslim women, in the world today.

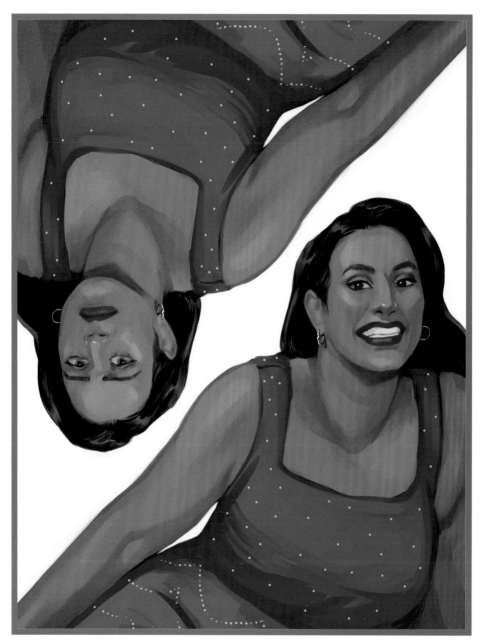

GOLD MEDAL

Maysoon Zayid, United States

IF THERE WERE an oppression Olympics, Maysoon Zayid says she would win the gold medal. In a TED Talk that went viral and became the most watched TED Talk of 2013, the thirty-eight-year-old comedian listed her oppressions:

Palestinian.

Muslim.

Female.

Disabled.

From New Jersey.

Maysoon was born with cerebral palsy, a movement disorder caused by brain injury or malformation before, during, or soon after birth. While giving her famous TED Talk, *I Got 99 Problems . . . Palsy Is Just One*, Maysoon stands up from her chair to show the audience how she shakes, and swears she's not drunk.

The struggle started early. Maysoon's elementary school principal told her parents she couldn't attend public school and had to go to a school for children with Down's syndrome instead. Her parents refused, sued the school, and won. Her dad's mantra was always "You can do it, yes you can can," which imbued Maysoon with a can-do attitude that persisted into adulthood.

With no money for physical therapy, Maysoon was sent to performance classes at age five, igniting her dreams of becoming a Hollywood actress and starring in the ABC hit show *General Hospital*. Onstage, she felt an "unlimited energy," but when she went to Hollywood as a young woman, the industry rejected her talents.

People with disabilities are the largest minority in the world but the most underrepresented group in entertainment, making up one-fifth of the population but two percent of the images we see in the cinema or on TV screens. Even when storylines include disabled characters, nine times out of ten those characters are played by nondisabled actors. Maysoon learned this early on. At Arizona State University, where she studied on an academic scholarship, Maysoon was turned down for the lead role in a play

"REPRESENTATION MATTERS.
SEEING PEOPLE WHO LOOK LIKE YOU,
SOUND LIKE YOU, AND COME
FROM THE SAME PLACE AS YOU MAKES
DREAMS FEEL POSSIBLE."

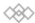

about a girl with cerebral palsy. An actress who was not disabled was chosen to play the role instead. That wasn't the only sting. On her very first day in an English literature class, Maysoon's professor asked her if she could read.

We laugh, we cry. We laugh to keep from crying.

Representation matters. Seeing people who look like you, sound like you, and come from the same place as you makes dreams feel possible. But there have been few who paved the way for a disabled Palestinian Jersey Girl with a knack for punch lines and reducing a crowd to tears. "I just didn't see myself on TV, and if you can't see it, you can't be it," Maysoon says. But she could see herself in comedy. "Comedy is a place for misfits, and I was a misfit."

Maysoon might be the first stand-up comic in the Arab world and the first Muslim American woman comic, but she doesn't like to claim those titles, knowing how women are pitted against one another, knowing how room is made for very few women and Muslims to penetrate white, male-dominated spaces such as the entertainment industry.

Maysoon makes jokes about everything: religion, disability, terrorism. She quit her job as an English teacher to become a comedian in 2001, right as the September 11 attacks happened in New York City. The next year, she was the first person ever to perform stand-up comedy in Palestine and Jordan—a title she is very happy to claim. In 2003, Maysoon cofounded the New York Arab-American Comedy Festival with Dean Obeidallah. Hate crimes against Muslims, and those perceived to be Muslims, increased 1,617 percent after the September 11 attacks. Comedy was a way to survive hate.

"I feel like doing comedy is a fight for our lives," Maysoon says. "I tell people all the time that if you make someone laugh, they're less likely to kill you." She pauses. "They may still do it—but they are less likely."

Perhaps this is why *Glamour* magazine called her "The Most Fearless Comic Alive." Or perhaps it is because of the death threats Maysoon receives for daring to be funny and Muslim and a disabled woman—refusing to be quiet, refusing to pipe down and stop making jokes in the face of violence. "Women with disabilities are three times as likely to face violence in their lives, so in addition to being Muslim, I'm a disabled woman in this country who wakes up every day wondering, 'Will I have healthcare tomorrow or will I not?'"

Maysoon is currently writing and set to star in her own ABC primetime TV sitcom, *Can-Can,* echoing her father's encouraging mantra to her throughout her youth. *Can-Can* is a show about a disabled Muslim woman, Muhammadia Ali, aka Mimi, who is navigating life and love. In a meeting with ABC executives to discuss her development deal for *Can-Can,* you might have expected Maysoon to demand a clause in her contract that would satisfy her childhood dream of making a cameo on *General Hospital.* She did ask for that. But she also told the suits, "I need you guys to make [*Can-Can*] because it's the only thing that's gonna keep me out of an internment camp." The pilot began filming in January 2019.

Maysoon is often asked what's scarier and more difficult, being Muslim or being disabled, as if she gets to choose which identity she will wear that day. She counters the asinine questions with wit, demonstrating her agency and control. There is power in making jokes, in telling our stories unfiltered, without apology, with a smile.

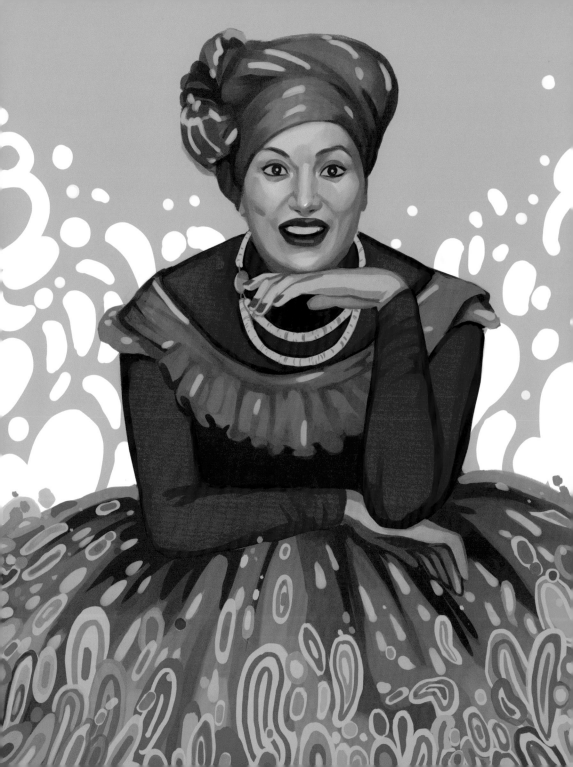

WOMAN OF COLORS

Samia Orosemane, France

WHEN SAMIA OROSEMANE is onstage, it feels like she is the center of the world. "People only look at me. I can make them laugh, cry, reflect, and it's magical," says the French-born Tunisian comedian who is known for her vibrant, patterned turbans and kaftans. But assuming her rightful place on the stage has not been easy. Born in Paris and raised in Clichy-sous-Bois in the eastern outskirts of the capital, Samia tried her hand at acting in college while she studied social sciences and the works of French poet and playwright Molière. That led her to France's prestigious and competitive drama academy, Conservatoire National Supérieur d'Art Dramatique. But despite her talent as an actress and comedian, success in the entertainment business seemed elusive for a French Tunisian woman in a hijab. Samia took up jobs as a factory worker and nanny instead.

As she pondered how to turn comedy into a career, her hometown, famous for its African immigrant communities, erupted in violence. In the fall of 2005, police continued their harassment of young North African men and sparked riots that lasted three weeks. Clichy-sous-Bois, only twelve miles from Paris, but considered one of the city's most isolated suburbs, burned as the world looked on. Samia watched her neighborhood disintegrate, and with it, her hopes of becoming a comic. Hatred toward people of African descent soared after the riots. Arabs were already eight times more likely to be stopped by police than white people, and black people six times more likely to be stopped—after the riots, the situation worsened.

While working odd jobs, Samia began to knock at the doors of comedy clubs, offering stand-up routines about life as a Muslim woman in France. But doors kept closing in her face. Comedy club managers asked her for video reels, a detailed résumé, a biography, and a list of performances, a long list of demands for only three minutes on the shabby stage of a basement club. Samia grew fed up and decided to create opportunities for herself and others like her. Inviting a group of lesser-known and equally struggling comedians to join her, she organized her own comedy show. In exchange for a platform, Samia

challenged the emerging comics to make audiences laugh without using profanity. She wanted to show the critics that Muslim comics had a broad appeal and could entertain family audiences. She called the show *Samia et les 40 comiques*, a play on Hanna Diab's famous folktale, *Ali Baba and the 40 Thieves*, and toured the troupe through France and Belgium beginning in 2009.

At first, their audiences were mostly Muslims and people of African descent, many from the kinds of neglected suburbs where Samia lived and grew up, and the press showed little interest in a bunch of Muslim comics and their Muslim fans. "In France people feel the need to put people into categories. If people are white and they do comedy, it's considered culture. But as soon as you're dark-skinned, it's seen as only relating to and being funny for your ethnic community," Samia said. Her humor poked fun at colorism, interracial relationships, and strict parents, addressing universal themes familiar to many Europeans.

Slowly, Samia's audience began to diversify, and when she launched her one-woman show, *Femme de couleurs*, in 2012, the crowds lining up to listen to her jokes represented a wider swathe of French society. There were Muslims and Christians and atheists, liberals and conservatives, and Samia could make them all laugh. The show, which was named after her wardrobe of colorful turbans and kaftans, toured Europe and North Africa.

But just as her career was gaining traction, a terrorist attack in 2014 prompted more anti-Muslim rhetoric and ignited a different kind of response from Samia. Wearing a green hijab wrapped around her neck, and not her trademark turban, a frustrated Samia looked straight into the camera and spoke directly to the jihadists who had perpetrated the attack. "We're tired. It's already complicated to live here in Europe. If on top of everything you start to bring all the hatred toward us, it starts to get a little bit too tiring, you know? So please choose another religion. Thanks. Bye."

The video went viral. But in January 2015, three months after she recorded it, terrorists attacked the offices of French magazine *Charlie Hebdo*, and Samia's video spread even farther and garnered nearly a million views. Her candidness and honest outrage were featured in *Huffington Post* and Al Jazeera. In newspaper interviews profiling her viral success, she made fun of the relative ease of converting to Islam: "I mean, all you need to do is say two sentences, and you're in!"

The response to this attack from some French citizens and politicians was a demand that Muslims everywhere denounce terrorism and embrace Western culture, as if death and horror are automatically endorsed by 1.8 billion people. Samia's viral video made her the go-to figure for the frustrated French Muslims who reveled in her wit and honesty. Her comedy offered clarity. After the viral video, fans said they turned to Samia's social media pages as soon as a political event occurred, hoping to find a humorous analysis that could help them make peace with the world and their place in it. But there was a downside. It was her response to terrorism that had gotten her noticed, not her jokes about pushy parents or arranged marriages. Samia yearned to be heard when she spoke on other topics, not just ones interwoven with terror. She wanted to tell jokes about the family drama that erupted when she married a Black man from the Caribbean, jokes about colorism in her North African community, gender roles, and her constant inability to cook a good meal.

By writing her own characters and alter egos, and organizing her own shows, Samia continues to make room for herself in a culture that tries to silence and censor Muslim women. Where doors were slammed shut and stages made off limits, Samia has wrenched them open and invited other Muslim comics to take up space with her.

"BY WRITING HER OWN CHARACTERS AND ALTER EGOS, AND ORGANIZING HER OWN SHOWS, SAMIA CONTINUES TO MAKE ROOM FOR HERSELF IN A CULTURE THAT TRIES TO SILENCE AND CENSOR MUSLIM WOMEN."

MUSLIM WOMEN DANCE

IN A WORLD that prescribes how women should move and where we can go, commandeering a stage and stomping heels to a rhythm can be the height of rebellion. Muslim women are doing just that, in hijabs and tutus, abayas and shell-toed Adidas. Muslims have varying beliefs about music and dance, but Islam and the regions it infiltrated have long histories of worship through movement. The swirling dervishes of Turkey twirl themselves into a rapturous trance in devotion to Allah; Malabar's Muslims bend at the hips and sway in a dance called Duff-muttu; the undulating soft hips and belly rolls of raqs sharqi (simpli-fied and sexualized as "belly dancing" in the West) began as a way for women to entertain other women and prepare for childbirth.

Muslim women move their bodies to shake off the day and tell a story. Thumping hearts, shaking thighs—we dance to sweat, to feel sexy, to feel in control of our bodies. We dance to claim our space, to shimmy through stress and love and joy. We dance to our own beats, finding freedom and sisterhood in movement.

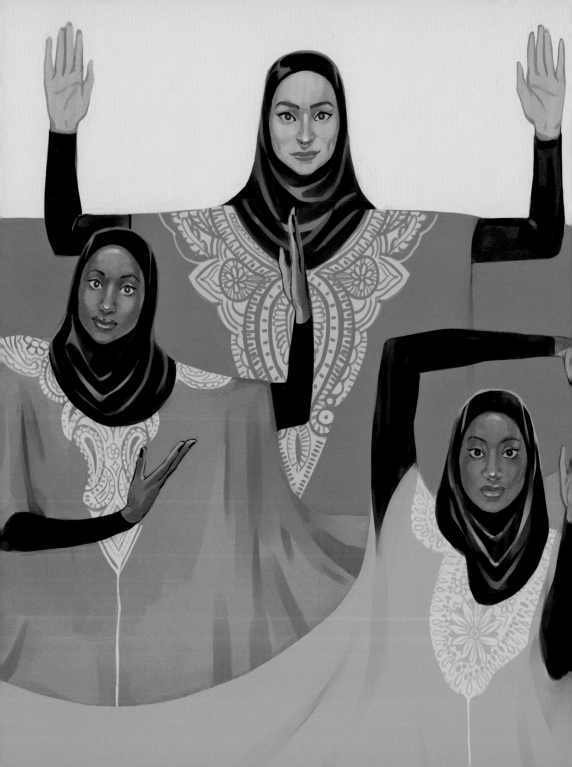

WE'RE MUSLIM, DON'T PANIC!

Khadijah Sifterllah-Griffin, Iman Sifterllah-Griffin, and Amirah Sackett, United States

TWO BLACK GIRLS walked into a dance studio in downtown Minneapolis, Minnesota, lip gloss poppin', headscarves pinned to perfection. The dancers there looked them up and down, their eyes lingering on the girls' hijabs. They assumed the thirteen-year-old sisters couldn't dance and challenged them to a battle. Accustomed to pushing back against stereotypes and misconceptions about their religion, the twin sisters shrugged and accepted. Then they popped, locked, 'n' whacked their competition into the ground.

"Don't let the hijab fool you mm-hmm," says one of the twins, Khadijah Sifterllah-Griffin.

"Watch out for me cuz I'm America's next top Muslimah," says her sister, whose name, Iman, is embroidered across her hijab. "When people look at me they don't think I look like I'm a dancer," Iman says. But the pair are experts in popping, the 1970s funk dance born in California, and whacking, a style created in the 1970s by queer Latinx and Black dancers.

Across the studio, hip hop choreographer and dance instructor Amirah Sackett nods her head. Amirah can relate to the sisters' experience. The scholar of hip hop dance and culture, trained in ballet, breaking, and contemporary dance, who pops 'n' locks in hijabs and flowing gowns, knows what it is to be eyed up and down, judged and undermined. "If you saw me walking down the street you probably wouldn't think I could take you in a dance battle," says Amirah, a black-and-silver hijab draped over her head sparkling as she speaks. "But I can!"

Amirah counts Islam and hip hop as central parts of her identity. A child of 1980s Chicago, she grew up memorizing surahs and Mos Def lyrics, matching Adidas tracksuits and high-tops with hijabs. Studying ballet as a child, she heard her mother mention a new and "dangerous dance" that the cool kids were doing. It involved spinning on your head and knees, freezing in athletic positions, and challenging others to dance battles. The dance style was called "breaking" (to practitioners, the word "breakdancing" is considered a nerdy, even derogatory term). Amirah's love affair with breaking was sparked, and she vowed to become a B-girl. She studied the Rock Steady Crew in the 1983

movie *Flashdance* and counts pop master Fabel, a Muslim of Puerto Rican descent and star of the 1984 movie *Beat Street*, among her mentors. But early on, these passions felt at odds with one another. What did the four elements of hip hop—rapping, deejaying, graffiti-writing, and B-girling—have to do with Islam's five pillars—charity, faith, fasting, pilgrimage, and daily prayer? And how could she reconcile what she read in the Qur'an—verses about women dressing modestly to hide their bodies—with her need to evoke emotion and tell stories using her body? Amirah kept her practice of Islam and hip hop separate, but both lived inside her.

Her favorite rappers were Black Muslims who, through lyrics about Sunni Islam, the Nation of Islam, and the Five Percenters, were dropping gems about what it meant to be Muslim in America. Amirah learned there was more depth to hip hop than she originally thought, including the central tenets of activism, civil rights awareness, justice, political awareness, and community awareness. It wasn't long before Amirah was drawing parallels between the cypher circles of hip hop and the prayer configurations of her faith. "As a dancer, we dance in a cypher, in a circle. When you get in that circle, it's about the skills that you have. It doesn't matter what color you are, it doesn't matter how much money you have, it doesn't matter," she said on Hawaii Public Radio. "The cool thing about praying in Islam is that we pray in a straight line. We pray shoulder to shoulder, and you might be next to a taxi driver and you might be next to a doctor and you'll be next to someone from Egypt then someone from Somalia, and you're all praying together . . . I find the cypher and prayer to be a similar feeling for me. Love and unity."

But love and unity aren't the first things that come to mind for some when they think about Islam, thanks to media representation focused on violence perpetrated by a minority of people in the name of religion. So when Amirah met twin sisters Khadijah and Iman while she was teaching dance in Minnesota in 2011, she had an idea. The twins, who were raised by an African American father and a Jamaican mother on a diet of dancehall and reggae, possessed phenomenal talent. They had learned techniques from their mother and studied West African dance as well as African American styles such as crunk. Amirah wanted to work with the twins to develop a dance that would spark a national conversation. "I decided as an artist it's time to use my language of dance, my medium of hip hop, and my identity as a Muslim and American and say something."

The sisters were delighted. "Amirah Sackett was the first Muslim dancer woman who we met in Minneapolis, who moved like us, who's a popper. When we met her we were like, 'Where have you been?' She's an inspiration," said Iman, in an interview with hip hop professor Dr. Su'ad Abdul Khabeer. Amirah asked the twins' mother for permission to do something that she described as potentially "a little controversial." Their mother agreed, and hip hop dance trio We're Muslim, Don't Panic! was formed.

Onstage, the three dancers stand in a line wearing burqas, niqabs, and shell-toe Adidas. The beat drops. Their arms extend, palms facing outward in the universal symbol of submission. But these are women in command of the stage and their bodies, "superheroes," according to Amirah, women who strive to reflect the power of the influential Muslim women in their lives through dance.

Shortly after they began performing as a group, a video of their performance went viral. Amirah's plan to use dance as a way to communicate the experiences of Muslim American women and girls and to challenge stereotypes had worked. *Huffington Post* called it the "Dance Routine We Can't Stop Watching," and the trio was interviewed by several international news outlets. They won the prestigious Sage Cowles Award for Best Ensemble Performance for Amirah's choreography and their performance in "Mourning in America," a 2013 music video by rapper Brother Ali. What had once felt to a young Amirah like conflicting ideas and passions—her religion and her hobby—had merged to showcase her entire experience as a Muslim American woman who wore hijab and used dance to express herself. "Having multiple identities gives you a gift, the gift to bridge," Amirah says. The U.S. State Department agrees. In 2014, Amirah was appointed Cultural Diplomat and visited Malaysia and Bangladesh for a hip hop cultural exchange program and to share her experience of being a Muslim woman in America.

Swaying palm trees and the rolling waves of the Pacific Ocean form the backdrop for Amirah's 2017 solo performance, "Qadr," based on the poem "The Alchemy of Love" by thirteenth-century Sufi scholar and poet Rumi. At the Shangri-La Museum of Islamic Art, Culture & Design in Hawaii, Amirah dances beside the beach next to ornate Islamic carvings as she develops movements that explore the ways we build walls around ourselves and each other.

"CHOREOGRAPHING OUR MOVEMENTS THROUGH STREETS AND STAGES, BENDING OUR BODIES THE WAY WE DESIRE, MUSLIM WOMEN DANCERS TAKE CONTROL IN A WORLD THAT TRIES TO DEFINE WHAT IT MEANS TO BE MUSLIM, A WOMAN, AND A PERSON OF COLOR."

The twins are finding freedom and expression in dance, too. The sisters formed a dance duo called Al Taw'am, Arabic for "the twins"; won the National YoungArts award; and became the youngest recipients of the Sage Cowles Award for dance. "Being African American, and being women, and being Muslim, that's like triple terror," Iman says. "Being all three of those in America isn't always easy."

Choreographing our movements through streets and stages, bending our bodies the way we desire, Muslim women dancers take control in a world that tries to define what it means to be Muslim, a woman, and a person of color. "Islam and hip hop are two of my favorite things," Amirah says during a TED Talk in New Hampshire. "Today . . . I feel the need to define and defend both." As Black culture and Islam are each scrutinized, misconstrued, and appropriated, Amirah, Iman, and Khadijah take ownership of their histories and their bodies, moving in time to a beat they choose.

KEEP ON DANCING

Stephanie Kurlow, Australia

STEPHANIE KURLOW was two years old when she started dancing ballet and nine years old when she was forced to stop because ballet schools in the suburbs of Sydney, Australia, refused to let her wear a hijab with her tutu. The message was clear: Her Muslim faith and her passion for dance could not coexist. To non-Muslims, a ballerina in a headscarf was unacceptable. To some Muslim traditionalists, the fact that a girl was dancing was unacceptable. Stephanie was stuck. But her Russian-born mother, Alsu Kurlow, who converted to Islam in 2010 when Stephanie was eight, kept searching for a studio that would allow her daughter to dance without changing her identity. When she was unable to find one, Alsu started her own. In 2012, she opened the Australian Nasheed & Arts Academy outside of Sydney, which offered ballet, martial arts, and aboriginal arts classes. The same year that the academy opened, Stephanie won first prize in a Muslim talent show and the Most Inspirational Young Star award in Sydney's Youth Talent Smash competition.

Stephanie, cited as the first hijabi ballerina, counts figure skater Zahra Lari as a big inspiration to her. Zahra is the first figure skater to compete wearing hijab, the first Emirati figure skater to compete nationally, and the only hijabi athlete on the international skating scene. Zahra lost points for wearing a hijab during a competition in Italy in 2012 because some judges said her hijab was a prop despite the fact that it sat firmly on Zahra's head for her entire routine. Zahra kept skating while wearing her hijab anyway and the International Skating Union eventually changed its rules to keep up with the times, and with Zahra. A sponsorship deal with Nike soon followed and Zahra became one of the faces of the company's athletic hijab, which was launched in 2018. Her persistence, strength, and courage paved the way for Stephanie, who similarly refuses to let other people's narrow beliefs limit her movements. She is inspired by Misty Copeland and Michaela DePrince, Black American ballerinas who have continued dancing in the face of racism and hateful rhetoric.

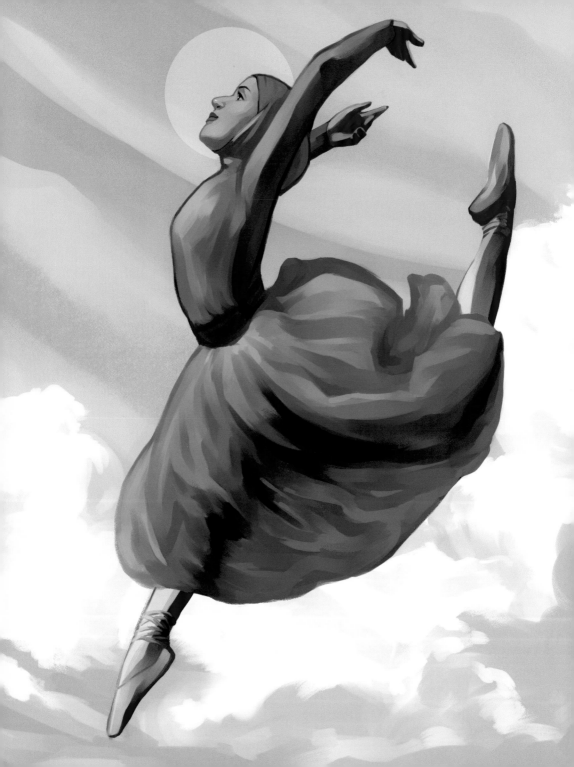

Stephanie keeps hearing that dance is not for Muslim girls, that a life of modesty and sedateness is the "right way," the pious way, and that she should not plié, chassé, and élancé. But Stephanie pirouettes anyway, arching her arms above her head, arcing her torso back until her turquoise hijab touches her lacy white tutu. "I believe [the hijab] covers my body, but not my mind, heart, and talent," she says. "Dancing is like flying for me. It makes me feel free."

"STEPHANIE KEEPS HEARING
THAT DANCE IS NOT FOR MUSLIM GIRLS, THAT
A LIFE OF MODESTY AND SEDATENESS IS
THE 'RIGHT WAY,' THE PIOUS WAY,
AND THAT SHE SHOULD NOT PLIÉ, CHASSÉ,
AND ÉLANCÉ. BUT STEPHANIE
PIROUETTES ANYWAY, ARCHING HER ARMS
ABOVE HER HEAD, ARCING HER
TORSO BACK UNTIL HER TURQUOISE HIJAB
TOUCHES HER LACY WHITE TUTU."

MUSLIM WOMEN MAKE NOISE

MUSLIMS ARE not a monolith. As heterogeneous as the languages we speak, the music we bump, and the food we eat, Muslim women refuse to squeeze into tidy categories or conform to stifling descriptors. We are cisgendered and trans, queer and straight, vanilla and otherwise. Sometimes we live our lives in private, other times we are loud and brazen and revel in the public eye. The Muslim women celebrated here are just a few of the game-changers and activists using their voices to scratch out the narrow definitions of what it means to be Muslim and woman. They fight for the freedom to read books, write poems, love who they choose to love—to live their lives on their own terms, exactly as they please.

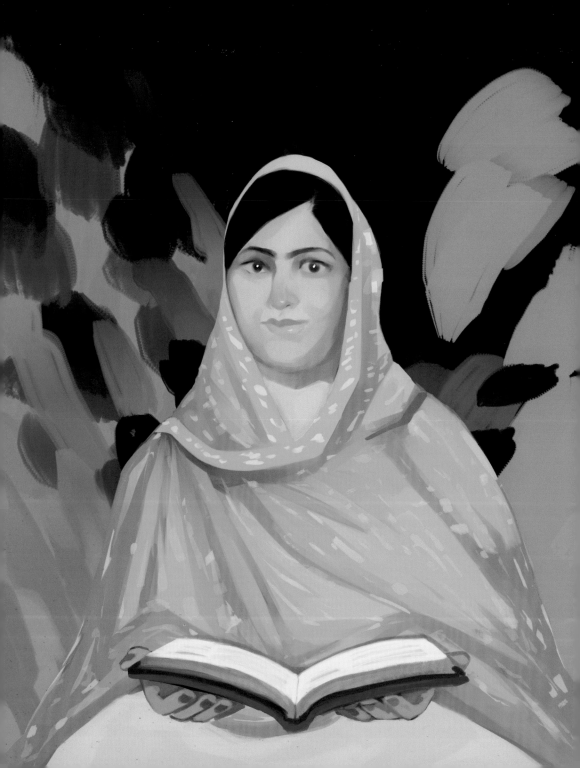

EVEN IF THEY COME TO KILL ME

Malala Yousafzai, Pakistan

MALALA YOUSAFZAI sat on the school bus one afternoon in October 2012 and looked out at the lush green hills of the Swat Valley, her home in the mountainous region of northern Pakistan. She was giggling with her best friend, Moniba, at the magic tricks the bus driver was doing with pebbles, relieved that the day's chemistry exams were behind them. Suddenly, two young men with guns boarded the school bus and shouted: "Who is Malala?" The then fifteen-year-old Malala squeezed Moniba's hand. The men opened fire on the teenagers, spraying bullets into the screaming group of schoolgirls. Malala's friend Shazia Ramzan was shot in the arm and hand and Kainat Riaz was shot in the shoulder. Malala was shot near her left eye and fell to the floor, unconscious.

Malala had been singled out by the Taliban, a fundamentalist political group, as a renegade teenager because she was a young feminist who had the audacity to demand that every girl have the right to an education. Malala had been vocal about this demand, blogging for the BBC since age eleven and rising to fame in Pakistan and around the world for her impassioned speeches.

The Taliban had transformed Malala's home in the hills of the Swat Valley from a picturesque holiday destination into a battlefield. Since 2007, the group had terrorized residents of the region, claiming land and establishing a tyrannical, misogynistic rule. Malala would wake in the night to the sound of bombs exploding. In the daytime, she passed the bodies of people murdered by the Taliban, their corpses left as warning signs to those who might dare disobey their commands.

Women and girls were forbidden from leaving their homes and banned from receiving an education under Taliban rule, but Malala insisted on going to school. Being a schoolgirl meant shoving textbooks under her tunic to hide them from men patrolling the streets with machine guns. It meant not wearing her school uniform in case the Taliban spotted her. Sheer terror kept girls at home and away from the classroom. At Malala's school, more than half the girls stopped attending. Walking the streets with textbooks, even if they were hidden, could mean death.

Four years before she was shot, eleven-year-old Malala addressed an audience at the Peshawar Press Club, a media organization in Peshawar, Pakistan, and asked, "How dare the Taliban take away my basic right to education?" Her father, Ziauddin Yousafzai, an educator and activist, had taken his daughter to the Press Club to speak about life under the oppressive regime. Soon after, he was asked by a BBC journalist to recommend someone to write a blog about life under Taliban rule because the original blogger had dropped out. Ziauddin suggested his daughter, and in January 2009, Malala began writing for the BBC's Urdu-language service.

Malala wrote for the BBC using the pseudonym Gul Makai, the name of a fierce, independent, and peace-loving heroine from a Pashtun folk tale. Malala shared her dreams of living in a world where she could go to school wearing a uniform, books brazenly on display in her arms—a world where she could fulfill her ambition of becoming a doctor and saving lives. She described the constant dread of existing as a girl in a world where women were hated and where Islam was distorted by men and used as a tool to oppress girls. "On my way from school to home I heard a man saying 'I will kill you.' I hastened my pace and after a while I looked back [to see] if the man was still coming behind me. But to my utter relief he was talking on his mobile and must have been threatening someone else over the phone."

Malala's blogs were read throughout Pakistan and much farther afield, with readers using the eleven-year-old's writing to urge the Pakistani government to fight back against the Taliban. Because she wrote under the name Gul Makai, Malala couldn't be identified, but something else threatened her family's safety. When the Taliban demanded that all girls' schools be shut, Malala's father, who had run Malala's school for more than ten years, refused to give in. Schools around the area were being bombed while others were taken over as Taliban military posts. Still, Ziauddin Yousafzai kept the doors to the girls' school open.

In the summer of 2009, as the Pakistani government launched a counterattack against the Taliban, Malala and her family were evacuated from their home in Mingora. Her father went to Peshawar and Malala stayed with family in the country. "I'm really bored because I have no books to read," she said in a documentary. When she returned home three months later, Malala shed the pseudonym of the folktale heroine, Gul Makai, and stepped into

her own voice. Malala means "grief-stricken" in Farsi, but the twelve-year-old was full of determination. She declared her mission was for all girls to go to school without fear of being killed. The president of Pakistan awarded Malala the first ever National Youth Peace Prize in 2011, and she appeared on talk shows, a documentary film, and in front of crowds of journalists and activists. Her boldness in speaking up against misogyny, religious extremism, and a tyrannical regime was breathtaking. She knew the Taliban was still circling. "Even if they come to kill me, I will tell them what they are trying to do is wrong, that education is our basic right," she said in a television interview.

The death threats began arriving the next year. In 2010, Malala's family began waking up to notes slipped under their front door demanding that Malala be quiet. Sometimes the death threats were published in the newspaper. In the summer of 2012, a committee of Taliban leaders voted unanimously to kill the schoolgirl who dared to seek an education.

When Malala was shot in the head on the school bus, the bullet pierced her skull, sending shards of bone into her brain, which caused the organ to swell. Her left ear was badly damaged. She was flown to Birmingham, England, for emergency surgery. Shazia and Kainat were treated in Pakistan, where the Taliban claimed responsibility for the attempt to kill Malala, and warned girls and their parents to stay at home and away from school. But support for Malala's struggle only intensified. One million people signed a United Nations petition asking Pakistan's president to make it safe for girls to go to school. Around the world, protestors waving "I am Malala" signs prayed for the schoolgirl's life and the safety of women and children living under oppressive, male rulers.

A series of surgeries left Malala convalescing in an English intensive care unit for months. Eventually, she was well enough to attend school in Birmingham, proudly wearing a uniform out in the open. And just nine months after she was shot in the head, Malala gave a talk at the United Nations about life under the Taliban regime. "The extremists were, and they are, afraid of books and pens. The power of education frightens them. They are afraid of women . . . Let us pick up our books and pens. They are our most powerful weapons." That speech was delivered on her sixteenth birthday, July 12, 2013, which the United Nations named Malala Day. The next year, Malala won the Nobel Peace Prize for her struggle. Malala was just seventeen years old, making her the forty-seventh woman and the youngest person ever to win the Nobel.

"THE EXTREMISTS WERE, AND THEY ARE,
AFRAID OF BOOKS AND PENS.
THE POWER OF EDUCATION FRIGHTENS THEM.
THEY ARE AFRAID OF WOMEN . . .
LET US PICK UP OUR BOOKS AND PENS. THEY
ARE OUR MOST POWERFUL WEAPONS."

Dreaming of her own education, she applied to study politics, philosophy, and education at Oxford University—the alma mater of Pakistan's first-ever female president, Benazir Bhutto. Malala marked her acceptance to Oxford with a tweet that was liked by 1.1 million people: "5 years ago, I was shot in an attempt to stop me from speaking out for girls' education. Today, I attend my first lectures at Oxford." Will Malala be a future president of Pakistan? Maybe a director-general of the United Nations? With a book under her belt, the world's loftiest awards, and the type of courage that inspires us to stand taller and dream bigger, Malala continues to fight for the right of girls to read books, write poems, and lift each other as we climb. And like Malala, her two friends Shazia and Kainat, who were shot by the Taliban gunman on the school bus, also dream of becoming doctors. The pair moved to Wales to study at a boarding school but plan to return to Pakistan to continue the fight until every girl is promised access to a free and safe education. "We are now symbols," Kainat said. "We should now inspire girls, especially girls from poor families."

PROVE YOURSELF

Sumayyah Dawud, United States

IN THE SUMMER of 2015, Sumayyah Dawud went to pray at her local mosque in Arizona, but was banned from entering. At the end of Ramadan, a handful of the congregation had complained to the board of directors of the Islamic Community Center of Tempe that Sumayyah "was not actually female." Men and women pray in separate areas in most mosques and praying next to Sumayyah in the women's section of the mosque made them feel uncomfortable, they said. Sumayyah was given two options if she was to continue worshipping at the mosque: either dress "like a man" or provide medical documentation to prove that she was a woman.

Sumayyah converted to Islam in 2013, three years after her gender designation was legally changed from male to female. Aware of the transphobia that exists in many Muslim communities, Sumayyah only told close friends that she was a transgender woman. But when leaders at the Islamic Community Center of Tempe demanded that she prove herself, Sumayyah handed over her government-issued identification that showed she was a woman. The Muslim leaders weren't satisfied. They demanded medical records. Sumayyah provided information from her doctor, and the chairman of the mosque's board of directors promised no one else would see the private medical documents. Then he publicly outed her and kicked her out of the mosque. Sumayyah recorded a video documenting her struggle and her commitment to fight for the rights of transgender Muslim women.

Born and raised in Arizona, Sumayyah is a human rights and environmental activist. In online videos, she can be seen wearing her niqab and burqa and bravely confronting right wing, anti-Muslim protestors rallying against the freedom of Muslims to worship in America. Oppressed by those within her community and persecuted by those outside of it, Sumayyah said Islam motivates her continued struggle for equality. "Islam in general strongly values those who strive in the face of difficulties and do not give up," she said in an interview with GLAAD, an American organization that promotes understanding and tolerance of queer people. GLAAD ran a series of interviews with transgender Americans of faith to celebrate transgender people who follow a spiritual practice.

Sumayyah talked about her religious journey, including her study of world religions that led her to become a Muslim. "Islam encourages Muslims to be patient, always trust in Allah, and to stand up for ourselves and others who are oppressed or face injustices."

Two years before Sumayyah was ostracized by a Muslim community in the United States, a Muslim transgender woman was kicked out of her mosque in the United Kingdom. Lucy Vallender was banned from entering a mosque in Swindon, where Muslim leaders said she had to pray in the men's section of the mosque for "health and safety" reasons. A white English woman, Lucy had converted to Islam the previous year after studying the religion and finding it promoted peace. Leaders at the mosque quickly dispelled that teaching. They asked Lucy about her bra size and menstruation and asked to see her birth certificate. She went home to pray. "I just want to live my life like a human being and be treated like a human being," she said on the *Daybreak* morning television show.

Britain's tabloid press labeled Lucy the country's first transgender Muslim woman, a lonely and false designation that undermines the long history of transgender Muslim people around the world. But the violent combination of transphobia and Islamophobia means many queer Muslims are forced to live their lives in isolation.

In Indonesia, the country with the largest Muslim population in the world, transgender people are known as *waria,* a portmanteau of the Indonesian words for "woman," wanita, and "man," pria. Waria are visible in Indonesian culture in movies and music. When President Barack Obama was a child growing up in Jakarta, his nanny was a Muslim waria woman called Evie. In Yogyakarta, waria Muslims established their own mosque, Al Fatah Pesantren, in 2008, as a place to pray, break fast in Ramadan, and find community. Worshipping in other mosques meant being stared at by people unable to reconcile narrow gender norms with the reality that gender is a social construct, and this space allowed any Muslim to practice openly and safely, regardless of how they identified.

Finding and practicing faith can be an internal struggle, a grappling of ego and desire, a lifelong fight to find peace, live a purposeful life, and grow closer to a higher being. It should not be a fight for acceptance and community, or persecution. Sumayyah Dawud is undeterred by the haters. "As a transgender woman who has been oppressed both inside and outside of the Muslim community, I find solace and guidance from Islam on how to be myself and grow in my faith."

MUSLIM COOL

Su'ad Abdul Khabeer, United States

DR. SU'AD ABDUL KHABEER was grooving to the music at a basement house party in Chicago, hips dipping and rolling as she and her friend Latifah gradually shimmied their way to the center of the makeshift dance floor. Arabic pop songs blasted as the crowd of mostly Arab American women got down. But as Su'ad and Latifah reveled in the tunes and enjoyed the sanctity of a space for only Muslim women, a space where they could shed headscarves and quite literally let their hair down, the Arab American women distanced their own bodies so they could watch the pair. Su'ad and Latifah, two Black women in a room of mostly non-Black people, had become a spectacle—women the others observed from a distance.

Su'ad is a hip hop professor; a scholar of race, culture, and Islam; an expert in anthropology; and a longtime poet and activist. She tells this story of the house party in her book, *Muslim Cool: Race, Religion, and Hip Hop in the United States*, describing how the party was divided along the lines of "good Muslim girls" in hijabs on one side of the basement, and "bad Muslim girls" who used the language and fashion style of hip hop culture on the other. The "bad Muslim girls" were exploiting Black culture to go against the grain of what was acceptable in their own culture, a way of showcasing their supposed tenacity and rebellion.

Black Americans make up one-fifth of America's Muslim population, according to a 2019 report by the Pew Research Center, and yet, the American mainstream centers Arab American and South Asian Muslim experiences when it talks about Islam, inviting Arab Americans and South Asians to write op-ed columns in newspapers and to speak on behalf of all Muslims as pundits on cable news. Islam is often racialized and made synonymous with any people from the Middle East and Asia, although more than three-quarters of Arab Americans are Christian, according to the Arab American Institute. Talking about Islam is yet another place where the racial divide is evident, and the Black Muslim experience is often negated in conversations about Islam in America.

"MUSLIMS HELP DEFINE WHAT IT
MEANS TO BE AMERICAN, SHE ARGUES, AND
BLACKNESS IS AT THE HEART
OF THE AMERICAN MUSLIM IDENTITY."

The period after the September 11 attacks, and the Islamophobia that followed, led Su'ad to graduate school at Princeton University to study the influence of Black Muslims. This divisive period was also an impetus that brought Arab and South Asian communities together in the fight toward religious tolerance and racial equity. But Black Muslims had been doing that work for decades—their survival depended on it. This degree, and Su'ad's experience with years of racial justice work, led her to write *Muslim Cool*, in which she analyzed friendships between Muslims of different races and ethnicities and unraveled the complicated tangle of faith, pop culture, and race. Notebook in hand, she spent months in Chicago's Muslim communities studying Arab American, South Asian, and Black Muslims. She found that her Ivy league affiliation and fluency in Arabic helped her move through Arab American and South Asian Muslim communities that, at times, treated Black Muslims, like herself, as outsiders.

To further this cause, in 2015, Su'ad founded Sapelo Square, the first website dedicated to celebrating and centering the Black Muslim experience. Its name comes from

Sapelo Island, a block of land off the coast of Georgia, which was home to one of the first African Muslim communities in the United States in the early 1800s—a community of enslaved Africans who had to fight to hold on to their Islamic heritage. In 2018, CNN named her one of the twenty-five most influential American Muslims.

Su'ad has spent her career trying to change the perceptions of and expand the idea of what it means to be a Black Muslim in America. The hip hop professor says many people think of a bearded brown man who doesn't speak English when they think of a Muslim. They don't picture the members of Grammy Award–winning rap group A Tribe Called Quest, who joined comedian David Chappelle on *Saturday Night Live* a week after the 2016 US presidential election. The group performed alongside rappers Busta Rhymes and Consequence, meaning there were five Black Muslim men on American television at a time of violent anti-Muslim rhetoric. The members of A Tribe Called Quest are openly Muslim, and their TV performance that night spoke directly to the hate crimes and the new administration, but the men weren't celebrated as Black Muslims. "They didn't talk about them as Muslim men, not because their Islam is hidden—because it isn't—but because their Islam doesn't look like what they think Islam should look like," Su'ad says in the CNN video. That erasure of Black people from the American Muslim experience ignores a legacy that dates back hundreds of years, including activists such as Malcom X who mobilized movements and inspired millions.

Su'ad grew up in Brooklyn, New York, listening to Muslim rappers like Yasin Bey (who was formerly known as Mos Def). Hip hop is "replete with Islamic references and pro-Black and pan-African messages," she says in an interview with the *Atlantic* magazine. Muslims might be feared and ostracized by mainstream culture, but Su'ad argues that in America, hip hop, Black culture, and Islam influence what is cool. All of them contest the mainstream. And while others might argue that hip hop, Blackness, and Islam languish at the margins of American society, Su'ad's scholarship takes American Muslims and Blackness out of the margins and places them right at the center of American culture. Muslims help define what it means to be American, she argues, and Blackness is at the heart of the American Muslim identity.

WE HAVE ALWAYS BEEN HERE

Samra Habib, Pakistan

SAMRA HABIB is familiar with living a life on the margins—and busting out into the center of the page.

Born in Pakistan, a Muslim nation by its very inception and definition, Samra's family belonged to a minority Muslim sect considered blasphemous by Pakistan's Sunni Muslim majority. Her family are Ahmadis, the most persecuted group in the country for their belief that Ahmadi leader Mirza Ghulam Ahmad is the messiah and the Holy Prophet Muhammad is not the final prophet. Worshipping in secret and hiding their faith from non-Ahmadis was part of daily life for Samra's family. In 1991, when Samra was ten years old, her family fled Pakistan for Canada, seeking refuge from worsening attacks.

Samra found community in an Ahmadiyya mosque in Toronto. Finally, there was the freedom to worship openly, to say "Assalamu-alaikum" to the Ahmadis, a blessing denied to Ahmadis in Pakistan, where many consider them non-Muslim. There was also the freedom to declare the founder of the Ahmadi sect, Mirza Ghulam Ahmed, the Promised Messiah. Ahmed was a reformist who established the sect in 1889 with an emphasis on nonviolence and, ironically, tolerance of other faiths. But many non-Ahmadis consider him a heretic. Samra's family had campaigned against that belief, fighting to end the persecution of Ahmadis in Pakistan. Her father, uncles, and grandfather lobbied for the Pakistan People's Party in the 1970s, a political group that promised to end discrimination against Ahmadis. But when the party rose to power, it declared Ahmadis to be non-Muslims. Violent attacks escalated.

In Toronto, a teenage Samra found freedom to worship openly in an Ahmadiyya mosque. But amid that newfound freedom, she found herself forced to conceal another part of her identity: her queerness. Could she be queer and Muslim at the same time? Samra felt that she was not Muslim enough—she didn't wear hijab, and she found it hard to see how her queerness and her faith could coexist.

"SAMRA FELT THAT SHE WAS
NOT MUSLIM ENOUGH—SHE DIDN'T WEAR
HIJAB, AND SHE FOUND IT HARD
TO SEE HOW HER QUEERNESS AND HER
FAITH COULD COEXIST."

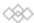

She received pressure from all sides: While at mosque, there was the pressure to conform to religious standards, and at home, there was pressure to marry a man, to be demure, passive, and quiet. Samra's parents did not want her to assert her identity, as that could be dangerous for her and lead to excommunication from the community they had risked their lives to join. On the margins again, Samra stopped praying at the Ahmadiyya mosque. It would be a decade before she stepped foot inside a mosque.

When she did find an open-minded spiritual community and a place to pray with like-minded Muslims, it was at Toronto Unity Mosque, a place of worship that embraces people of many backgrounds and sects. At Unity, Muslims of all genders are invited to pray alongside one another instead of being segregated by gender binaries, as they would be at most mosques. Unity was cofounded by El-Farouk Khaki, a human rights

lawyer; his partner, Tory Jackson; and retired professor Laury Silvers. Samra could be her whole self here: Ahmadi Muslim and queer and a feminist. At Unity, she prayed next to disabled Muslims, Shi'a Muslims, nonsectarian Muslims, queer Muslims. It was a holy place that nurtured her whole spiritual and creative self. She met many Muslims like her: Muslims who reconciled their faith with their queerness. People who were marginalized by an already marginalized group, people on the margins of the margins.

Finding solidarity in community, Samra decided to tell their stories. In a portrait project called *Just Me and Allah* launched in 2014, she took a camera to the streets to share the lives of people like her: queer, Muslim, refugee. She photographed Ari, who moved to France as a child when her parents were persecuted by religious extremists in Algeria. An activist and dancer who is "queering up" the Parisian dance scene, Ari looked into Samra's camera and said, "I call myself Muslim because of solidarity." There is Dali, a Malian transgender woman seeking asylum in Brussels because of transphobic attacks in her home country. "I just want to feel like I'm accepted in Islam as a trans woman," she says. "In my heart, I'm still Muslim. My regular reading of the Qur'an brings me peace." Within days of *Just Me and Allah* being published online, it went from internet photo project to social media phenomenon. Soon after it launched, *PBS NewsHour* said Samra's project captured "the diversity of Islam." *BuzzFeed*, *Huffington Post*, and other international news outlets featured Samra's work, and soon, she began receiving messages from Muslims around the world: messages of thanks and requests to be featured in the project.

Pointing to the fact that Islam forbids photography and therefore makes it hard to find evidence of queer Muslims throughout history, Dali, the transgender woman from Mali, said: "We have always been here, it's just that the world wasn't ready for us yet." That sentiment made it to the cover of Samra's memoir, published in 2019. In a nod to Dali, the title is *We Have Always Been Here: A Queer Muslim Memoir*. In its pages, Samra weaves together culture, faith, and immigration, as well as queerness, activism, and community.

Finding community lets us stand up and be counted. Seeing ourselves reflected in each other gives us the tenacity to live our fullest lives, to embrace the erotic, spiritual, and deliciously undefinable parts of our souls.

THINGS WE WEAR

FOURTEEN HUNDRED YEARS after the Qur'an was revealed, there is still debate about what Muslim women should and should not do with their bodies, and just as much deliberation about covering the head as there is about concealing the face. The choice to cover, or not, is a personal and spiritual choice for Muslims, and a political and cultural one influenced by geography, fashion, the law, and the weather.

Qur'anic verses promoting modesty of the body and the mind mention both women and men when offering guidance about covering the figure and lowering the gaze. But any discussion of modesty these days focuses almost exclusively on Muslim women, with male clerics weaponizing the Qur'an to control and encumber them.

The freedom to choose what we wear and how we wear it is also taken from us by the state. At least three countries—France, Belgium, and Austria—have banned women from wearing the niqab, while the Netherlands has a partial ban, and Denmark fines women for wearing the niqab or burqa. Germany has banned women from wearing the niqab while driving, and France banned women from wearing burkinis on beaches. Parts of Canada, Italy, and Spain have also banned the niqab and burqa. Turkey, on the other hand, banned hijab in the 1980s, despite it being a majority-Muslim country, but overturned the ruling in 2013.

If it isn't muftis declaring we *should* cover and politicians dictating we *shouldn't*, it's a fear of being attacked for daring to appear as visibly Muslim that impacts what we pull out of the closet each morning. Amid rising Islamophobia and oppressive regimes enacting narrow interpretations of Islam, some Muslim women feel unsafe wearing hijab, niqab, or burqa, or choosing not to wear them. On the beach, in the gym, at border crossings, our clothing and our bodies are policed.

What we wear is political and personal. Styling turbans out of silk and reclaiming our foremother's ornate yasmaks, Muslim women are rocking colorful prints or subdued fabrics as a declaration of faith or fashion, and sometimes both. Here are some of the ways we cover.

HIJAB

KHIMAR

TURBAN

SHAYLA

YASMAK

DUPATTA

BURQA

JILBAB

CHADOR

NIQAB

MUSLIM WOMEN BRING HOME THE GOLD

SOMETIMES BEING STRONG looks like blistered palms, metal bars, and a 6 a.m. boot camp workout. Sometimes, being strong smells like sweat and iron, and feels like a deep and satisfying ache in thigh muscles you forgot existed. Other times being strong sounds like saying "No," and smells like chocolate pudding; an evening of novels, scented candles, and gentle music. In a world that tries to dictate what a strong woman looks like, what she eats, and how she spends her time, Muslim women are conjuring new metrics of fortitude and success. In the face of *you must be a size double zero, Muslim girls cook and don't lift weights, grunting in the gym is not sexy,* and *aren't you scared of getting bulky?* Muslim women athletes and adventurers are strapping on oxygen tanks, dusting their palms, and lifting, diving, and soaring their way to new heights.

RUNNING A REVOLUTION
Nawal El Moutawakel, Morocco

BEFORE SHE WAS Morocco's first female Minister of Sports in 2007, even before she was the first Muslim woman elected to the board of the International Olympic Committee in 1998, Nawal El Moutawakel was hurtling down the racetrack, leaping over hurdles, and clearing four hundred meters of rubber in 54.61 seconds. On August 8, 1984, Nawal crushed the 400-meter hurdles at the Los Angeles Olympics. It was a brand-new racing category for women Olympians, and Nawal made history at the inaugural event. The twenty-two-year-old became the first Moroccan to win an Olympic gold medal, the first woman from a Muslim-majority country to win any Olympic medal, and the first African Muslim woman to become an Olympic champion. So momentous were her achievements that day that Morocco's King Hassan II declared that every girl born on August 8 should be named Nawal.

It's easy to celebrate women once they achieve the kind of success that elevates their nation and becomes a bragging point for male leaders. But Nawal's athletic journey was littered with men who believed women should train to be wives, not Olympians. Nawal's parents raised her to think outside the confines of her circumstances. Bucking the expectation that they'd keep their little girl at home to learn cooking and cleaning, her parents encouraged Nawal's barefoot races on the beaches near their home in the Bourgogne district of Casablanca. Flanked on one side by the Mediterranean Sea and by cheering children on the other, Nawal outran her brothers and sisters in sandy races. Their mother enjoyed playing volleyball, and their father, who practiced judo, motivated Nawal and her four siblings to compete in track and field. What began on the beaches led to an athletic club in Casablanca. When Nawal's older brother, Fouad, began to train there, Nawal followed in his tracks. She tried her hand at everything from shot put to cross-country running to high jumping, once flinging her body over a wooden rod and giving herself a black eye with her own knee in the process.

But sprinting was her forte. By seventeen, Nawal was outrunning her teammates, and her talents caught the eye of Moroccan officials who outfitted her in spikes and enrolled

her in formal training. Some said at five foot three inches tall she was too small to be an athlete, but Nawal didn't pay attention to their doubts. She excelled at hurdles, clearing wooden barriers that were taller than her waist. It was a sport she had described as "witchcraft" the first time she watched other athletes soar over the wooden barriers. By nineteen, Nawal had won two gold medals in the Arab championships, and by twenty, she was the African champion in the 100-meter hurdles. A chance encounter at the 1983 World Championships when she was twenty-one led Nawal to study in the United States, where her sprinting career would soar to dazzling heights. Nigerian sprinter Sunday Uti,

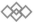

"HER GOLD MEDAL WAS MORE THAN A PERSONAL SUCCESS—ALTHOUGH SHE HAD SHAVED 0.76 SECONDS OFF HER PERSONAL BEST. IT WAS A WIN FOR MUSLIM WOMEN EVERYWHERE."

who studied and trained at Iowa State University, met Nawal at the Championships and told her he would pass on her information to his coaches. By the time Sunday had returned to Iowa, an acceptance letter with the offer of a full scholarship was on its way to Nawal's Casablanca home. But Nawal couldn't read English, and as a friend translated the details—that a full scholarship to an American university was worth tens of thousands of dollars and a really big deal—she wondered if her father would let her travel halfway around the world to run track.

Nawal's father said yes, and in January 1983, a nervous and shivering Nawal arrived in a snowy Iowa only to be met by university staff who doubted this petite brown woman

could be their new athletic star. They asked Nawal to run around the track before they were convinced they had picked up the right woman at the airport.

Disaster struck a week later, though the tragedy was kept secret from Nawal for months. Days after her arrival in a foreign land, her father was killed in a car accident in Morocco. Family members kept the devastating news from Nawal, knowing it would crush her and likely bring her back home. Instead, three months later, Nawal's brother traveled to Iowa to break the bad news. Nawal channeled her anger at the injustice of her father's death, and the secrecy of her family, into running harder and faster. She flew past her opponents on the field and became the National Collegiate Athletic Association's 400-meter hurdles champion and an All-American.

The Olympic Games were held only eight months after the death of her father, and a grieving Nawal arrived in Los Angeles with an injured ankle and a stomach bug. Fueled by sadness, determination, and years of training, she sprang into action with the sound of the referee's gun. Less than a minute later, history had been made and she knelt on the ground and covered her eyes in disbelief, not daring to look up at the results board. Had she really achieved what no other African Muslim woman or Moroccan had achieved before her? A phone call from King Hassan II confirmed the magnitude of Nawal's win. Her gold medal was more than a personal success—although she had shaved 0.76 seconds off her personal best. It was a win for Muslim women everywhere. Nawal's success cemented the Moroccan government's belief that athletics is for everyone, and that little girls should be encouraged to compete, a philosophy in line with that of Nawal's parents. "My mother and father let me do what I wanted to. We could have had many great female athletes in Morocco if the environment let them. Most start at thirteen and step out of sport at eighteen because they are told it is not something for girls to keep doing."

For years after her Olympic success, fan mail arrived in Iowa addressed to *Nawal el Moutawakel, Morocco*, in Arabic. Moroccan teenagers, elderly Arab men, veiled women, wrote letters of support and adoration. "I get letters every day from women saying, 'Thank you, you saved us,'" a twenty-five-year-old Nawal told the *Chicago Tribune* in 1987. In a world that believed Muslim women, Arab women, and African women should stay quiet, covered, and docile, Nawal became an emblem of the heights women can reach when given the freedom to pursue their dreams. But as she carried a Moroccan

flag over her shoulders during dozens of victory laps, Nawal felt the weight of a nation on her back. Phone calls from strangers demanded she keep winning "for Morocco." Women who wore niqab and those who didn't wrote Nawal to say that she had "liberated them." Newspaper headlines called her the "little Moroccan" and framed her success in bewildering terms. Her win was instrumental in the formation of women's sports organizations throughout the Arab world and Africa. While acknowledging the weight of those expectations, Nawal has never let the pressure stop her from continuing the sport she loves and advocating for women athletes. But she has spoken about the burden of representing a country and a religion and the coopting of one woman's own success for other people's gain.

Nawal now makes decisions at the highest level of sports. As vice president of the International Olympic Committee, she oversees the running of the world's top athletics events and helps decide which country hosts the Olympic Games. In her commitment to making sports accessible to women, Nawal launched Courir pour le Plaisir, a 5-kilometer race for women in Casablanca. Each year, more than 30,000 women run through the streets, weaving between mosques, palm trees, and cafes. It's about more than athletics, it's about liberation. Lacing up shoes, pounding the pavement, feeling your heart beat beneath your ribs are proof that you are alive and in charge of your own pace. Nawal says she "wanted to bring women outside to feel the power of sports together. It's like a mini-revolution."

UNAPOLOGETICALLY BRILLIANT

Ibtihaj Muhammad, United States

A TURN OF THE HEAD and a fleeting glance through a school window changed the course of Ibtihaj Muhammad's life. Sitting at a red light in the summer of 1998, Ibtihaj's mother noticed children playing a strange sport in a New Jersey high school. The children wore masks and long-sleeved white jackets and trousers. "I'm not sure what they're doing," she said, craning her head to look through the car window. "But they have on all of their clothes, and when you go to high school I want you to try it." A twelve-year-old Ibtihaj sat in the backseat wondering what her next athletic pursuit would entail.

Sports ruled in the Muhammad household. Ibtihaj's brother played football, and her sisters played volleyball. Their parents believed that excelling in sports would give the children a competitive edge for the rest of their lives, on and off the playing field. During the long summer holidays, Ibtihaj's father, Eugene, taught her and her four siblings how to swim and play basketball and baseball. Every summer, Ibtihaj was required to choose a summer sport, something to keep her active during the holidays. Her parents didn't mind what sport she picked, as long as she competed in something. By the time she turned thirteen, Ibtihaj had played half a dozen team sports including softball, tennis, and track. But there was one challenge, and it had nothing to do with athletic prowess. Each sport that Ibtihaj played required her mother to modify the uniform so that Ibtihaj could observe hijab and remain covered. Her mother sewed long sleeves onto her daughter's sports shirts and switched tight shorts for leggings and baggy sweatpants. The other kids noticed Ibtihaj's home-altered uniforms and poked fun. When Ibtihaj tried volleyball, her teammates, who wore spandex shorts, asked why she had to be different. She was often the only Black girl on the sports field, and a hijab and modified uniforms made her stand out even more. So the strange sport with its metal mask and long-sleeved jacket and trousers offered an unusual opportunity: the chance to play a sport wearing an unmodified uniform—the same uniform as all the other girls.

Ibtihaj took up fencing when she began attending Columbia High School in 1999. A sport with aristocratic roots that is typically the reserve of wealthy white people, Ibtihaj

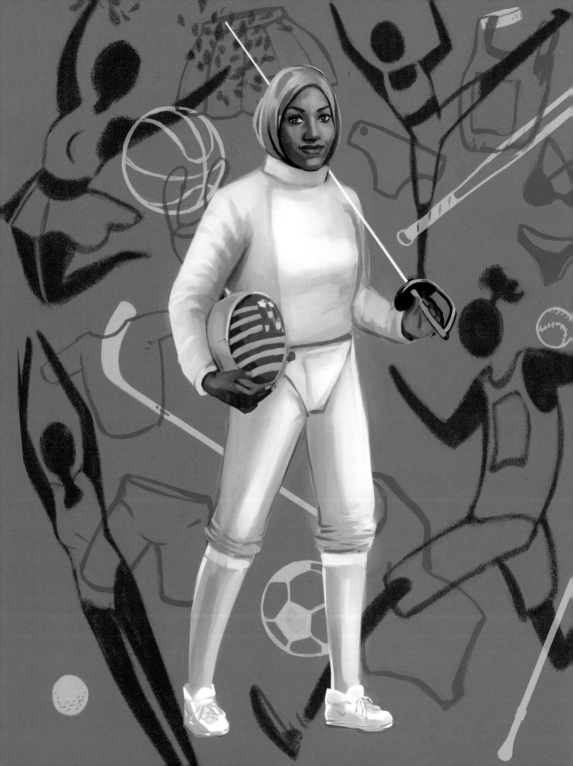

was the lone Black girl lunging and jabbing across the piste. With a hijab tucked beneath her fencing helmet, she scored points by thrusting at her opponent's head, torso, and arms. First, she tried épée fencing, which uses a bulkier sword, but her coach switched her to sabre, also known as the "Formula 1" of fencing. Sabre fencing uses a long and light weapon and requires speed, accuracy, and quick thinking. Ibtihaj dedicated hours to perfecting her technique and led Columbia High School to two state championships. She was selected to join the Elite Athlete Program in New York City, a prestigious training academy run by sabre fencing champion and five-time Olympian Peter Westbrook. But her achievements only heightened the racism and Islamophobia she experienced every day. Amid racial slurs, occasions when her name was butchered, and questions of why she couldn't be or look like the other girls who went to swim parties and sleepovers, Ibtihaj had to reckon with her own views of herself during a formative time. At first, the bigotry didn't dampen her love for the sport. But that would change at university.

By her junior year of high school, scholarship offers were pouring in, seeking to lure the brilliant athlete out of New Jersey. Ivy League schools such as Columbia University in the City of New York came calling, but it was Duke University in North Carolina that offered the most generous financial package. Ibtihaj wasn't sure. She was wary about life in the American South as a Black Muslim woman wearing hijab. She took the offer and moved to North Carolina only to learn that her fears were well-founded. At Duke University, she studied African and African American studies and International Relations and was a three-time All-American and Junior Olympic National Champion. The accolades kept coming—but so did the racism. Classmates at Duke remarked that Ibtihaj was only offered a place at the university because she was Black. On the fencing team, women athletes ostracized her and made hurtful and damaging remarks about her appearance and ethnicity. The racism provoked a visceral response in her—her stomach twisted into knots. During her senior year, the pressure forced Ibtihaj to quit the fencing team. Defeated, she went back home to New Jersey, struggled to find a job, and began to work in a dollar store.

Her high school fencing coach reached out to her one day and encouraged her to continue to train, to realize her true potential in the sport. But there was no one who looked like Ibtihaj in the world of fencing, no one who could promise the road ahead would get

smoother, less painful. Inspired by tennis champions Venus and Serena Williams, two Black women at the pinnacle of a white-dominated sport, Ibtihaj wished to be the role model for future Black girl fencers. "I remember being a kid and wondering why there wasn't an athlete who wore hijab, why there wasn't anyone who looked like me even in the fencing world that I could look up to for inspiration," she said. She would become that person. Countless hours of training, of psyching herself up to withstand the jabs and the slurs, led to a place on the United States National Fencing Team in 2010. An even more significant moment followed when Ibtihaj made it onto Team USA. For the first time in history, a woman in hijab would represent the United States at the Olympic Games.

But her rising prominence as a Black Muslim woman at the top of her game attracted death threats. Team USA officials fueled her fears for her safety by both sharing the threats with her and not taking them seriously. It was part of an Olympic team culture that Ibtihaj describes as toxic, a team culture in which she was treated like a pariah and made to endure psychological warfare. Teammates and instructors ignored her, left her off important team emails, and didn't invite her to meetings or group dinners. The treatment may have fueled her determination, but it came at a cost. The constant racism caused her to suffer depression.

Respite from the toxic situation came in the form of fashion. Balancing a rigorous training schedule with a dream to design beautiful clothes for Muslim women, Ibtihaj launched a fashion line, Louela, in 2014. The little girl who grew up making hijabs for her Barbie dolls was now in command of a company making modest clothing for an international clientele. But fencing remained her priority, especially as the 2016 Olympics approached. Ibtihaj continued to compete and accumulate points, hoping to qualify for the Games. The life-changing news came via a Google alert in early 2016 while she was competing at the Women's Sabre World Cup in Greece. Ibtihaj had earned enough points in that competition to qualify for the Olympic Games. Mathematically, no one could score enough points to knock her from Team USA and take her place.

But expectations of her success were low. There was little chance that the thirty-year-old would actually win a medal at the 2016 Olympic Games in Rio de Janeiro, Brazil, some people said, even if the president of the United States, Barack Obama, had personally asked her to "bring home the gold!" Team USA's women's fencing team was the

underdog, but Ibtihaj competed like her life depended on it. She was fighting for every little Black girl who had been told she wouldn't make it, that she wasn't good enough to succeed. In a crisp, pale gray hijab and a jacket with *Muhammad* emblazoned across the back, Ibtihaj lunged and stabbed and lunged and stabbed her way to success. The Black Muslim girl from New Jersey who had tried her hand at fencing because it offered a modest uniform made history as the first Muslim American woman to win an Olympic medal and the first American to compete in hijab. Holding her bronze medal in her hands, Ibtihaj signaled that hard work pays off, and that haters are gonna hate but winners always rise. "I wanted to challenge the narrative that Muslim women are meek and docile and oppressed. Being unapologetically Muslim, Black, and a woman, either you like it or you don't and I don't really care either way."

In her 2018 memoir, *Proud: My Fight for an Unlikely American Dream*, Ibtihaj writes about her path from Maplewood, New Jersey, to the Olympic village. "My journey is borne from other people telling me no, that it's not possible, that Muslim women don't fence, or Black kids don't fence. You're not fast enough. You're not strong enough." Ibtihaj is proof that we are enough. In 2016, the city of Maplewood, New Jersey, declared April 6 as Ibtihaj Muhammad Day, a testament to her brilliance and tenacity. For the Olympian, fashionista, and entrepreneur, the fight to live her best life and pave the way for others continues. "I've had to fight for every win, every place at the table, every ounce of respect on my path to world-class athlete. And I will continue to fight because the prize this time—an America that truly respects all of its citizens—is worth more than any medal. *Inshallah: so may it be.*"

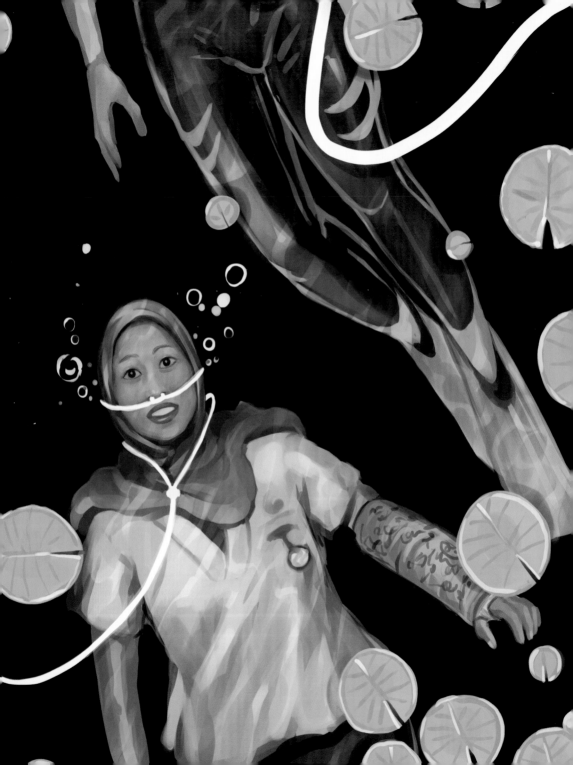

SCUBA-DIVING MIDWIFE

Ilyana Insyirah, Singapore

TAKING CARE of the sick was Ilyana Insyirah's way of giving back to the world, her way of serving God and living a life of purpose. But at age twenty-four, her nursing career was ended—and with it, nearly her life. In 2011, Ilyana and her sister were in a car accident that almost killed her, and left her with a broken neck, arm, and legs. Doctors feared she would be paralyzed and told her she would never work as a nurse again.

Four metal pins were drilled into Ilyana's skull to immobilize her head so the five fractured vertebrae in her neck could heal without impinging on her spinal cord. She underwent surgeries and plaster casts over her broken limbs. Still, in photos taken during the long healing period, Ilyana is smiling, her left hand throwing up a peace sign. Miraculously, she was not paralyzed, but her chosen career was over.

Ilyana possesses the kind of dust-yourself-off-and-try-again attitude that people read self-help books to try and emulate. Even with her dream career ended, she refused to give up. Instead, she went back to school, unsure of where this new course would lead but certain she would find a way to live a life of service. A movie screening in a sociology class one day revealed a way she could still care for the sick. *A Walk to Beautiful* tells the real-life stories of five Ethiopian women who walked hundreds of miles from remote villages in the country's deserts to the capital, Addis Ababa, in search of medical help. Each woman had suffered an obstetric fistula, a disfiguring disease often caused by a long and drawn-out labor where proper medical care is not given. Not only does the fistula cause physical distress and complications, including infertility, infection, and even death, but hundreds of thousands of women around the world are ostracized and abandoned by their communities because they suffer the disease.

Watching *A Walk to Beautiful* had a profound impact on Ilyana. Still on her own journey to healing, she resolved to help women and babies and work to lower maternal mortality and morbidity. She defied the odds and retrained as a midwife, quickly landing a job at King Edward Memorial Women's Hospital in Perth.

Becoming a midwife wasn't the only transformational change in Ilyana's life at this time: She decided to wear hijab. Australia offered her the freedom to do so, whereas Singapore, where she had grown up, forbade women working in the private sector from wearing hijab while in official uniform, even though one in six people in Singapore is Muslim. Still, it was a tough decision. "Being someone who came from a secular school and lives in a Western country, I was so afraid that the hijab was going to define who I am as a person and people would judge me based on it," she said in an interview for the website *Extraordinary Muslims*. "Being a minority in this country, especially being Asian, would already make me stand out." Instead, the hijab increased Ilyana's sense of connectedness to the Ummah, the global Muslim community.

Just four years after her car crash, Ilyana received Western Australia's Nursing and Midwifery Excellence Award in recognition of her efforts to help women and babies. It was an accolade she didn't expect to win. "I felt like I was just an Asian hijabi midwife, trying to find her way in life." She realized soon, however, that her calling was with working with the most impoverished women, so she left Australia for Tanzania to practice midwifery in a setting vastly different from her home.

With the hurdles of a new career and new aspect of her religious identity successfully overcome, she was ready for another challenge, this time an athletic one. In 2017, when she was worrying over turning thirty, Ilyana took six months off from work, traveled to Indonesia, and studied to qualify as an open water diver, despite the fact that the lingering effects of the injuries she sustained from her accident prevented her from hauling the oxygen tanks she needed to breathe underwater. With an instructor taking care of the tank, Ilyana was free to swim among manta rays, mola fish, and coral reefs. Ilyana advocates for Muslim women, especially those wearing hijab, to join her in the ocean. "We are just as capable of being scuba divers or instructors with or without hijab. In this day and age, when there appears to be so much hatred, we should show we are strong individuals and should not be judged according to what we choose to wear."

Broken bones, an ended career—these are challenges that could not stop Ilyana from plumbing the depths of her own resolve and finding the strength and passion to forge a new path and charter new territories. The hijabi scuba-diving midwife has not let other people's declarations of her capacity to heal, learn, or swim get in the way of her ambitions.

PAVING A PATH

Amna Al Haddad, United Arab Emirates

AMNA AL HADDAD had a career as a journalist writing about empowered women doing amazing things when she began a journey that turned her into the kind of role model she wrote news stories about. Amna had suffered crippling depression as a teenager, an illness that manifested in her in many ways, including extreme exhaustion and overeating. At nineteen, she decided she didn't have to settle for feeling unhealthy and unfit, and headed to Dubai's Safa Park, where she started to walk. Walking turned to running, which turned into a love affair with the gym, where she discovered a new facet of her personality: a competitive streak. Not content with machines and regular weight-lifting exercises, Amna learned the moves and techniques of Olympic weight-lifting and began competing in bodybuilding contests. "I never in my life thought that a walk—a simple *walk*—could actually change my life. But that's exactly what happened, because I took action, I took charge."

But the athletics bodies that governed weightlifting contests restricted who could compete by enforcing rules about what could be worn during competitions. In 2009, when Amna was perfecting her clean and jerks, the International Weightlifting Federation forbade women from competing in headscarves and unitards, effectively sidelining Amna and other Muslim women from the sport. Two years later, it loosened those rules and lauded itself for its "progressive strength." A year later, Amna took part in the Reebok Crossfit Asia Regionals as the first Arab woman ever to compete. In 2013, she made history as the first female weightlifter from the Gulf to compete wearing hijab. "I can lift a boy up," she said, lifting a bar stacked with metal weights above her head, as a *New York Times* reporter profiled her as one of only twelve women competitive weightlifters in the United Arab Emirates. She wasn't just competing against other athletes, Amna was fighting against a culture that tells women lifting weights makes them unattractive, that competitiveness should be saved for navigating marital pursuits, not perfecting deadlifts.

Inspired by the Pakistani American weightlifter Kulsoom Abdullah, who defied the rules for women competing while covered up and wearing hijab, Amna dedicated hours

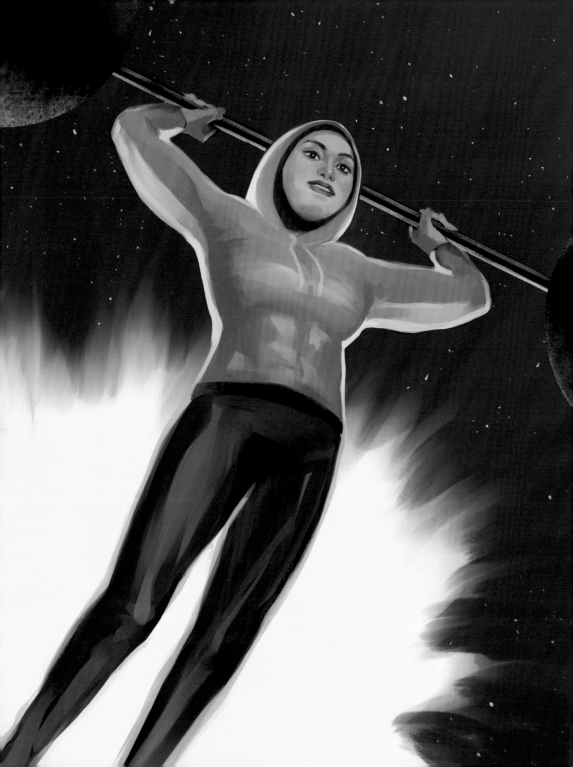

to perfecting her power cleans and muscle snatches, music streaming through her headphones. "There's a lot going on under the hijab," she said. Amna is also inspired by Najwan El Zawawi, the Egyptian athlete who represented her country in the Sydney Olympics in 2000. Najwan moved to the UAE in 2009 to set up a weightlifting program for women and trained Khadija Mohammad, the seventeen-year-old who became the first ever Emirati woman to compete in the Olympics in 2012. Najwan began to train Amna, too, who by 2016 had racked up six gold medals and three silver medals at International Weightlifting Federation events.

But along the path littered with medals, Amna struggled with depression, injuries, and the fight to balance her need to push herself while also taking care of her body. Amna was encouraged by a coach to move to Akron, Ohio, to train in the American Midwest. But when she arrived, a searing pain in her back worsened, and coaches told her to push through the ache. She overtrained and broke down. A doctor's visit revealed the back pain she had been pushing through was a serious disc injury.

Right when Amna was about to give up, she got a life-changing call: The UAE national team was preparing for the 2016 Olympics and wanted Amna to join them. She crowdfunded her way back to the UAE, worked through treatment, and scored enough points in the Asian Olympics qualifier in Uzbekistan to compete. But right when success seemed in reach, her back injury worsened, and Amna had to bow out of the Olympics. It could have crushed her. Instead, Amna looks at her road to the Olympics through the lens of gratitude and community. "Even though I didn't participate, I still consider my journey a success due to the shift it has brought to the pool of talent of Emirati female athletes," she told *Vogue Arabia*.

Her persistence and determination inspired global sporting brand Nike to recruit her as an ambassador. "I was not given the tools or the circumstances. I just created it and I made it happen," she said while lifting weights in a Nike training video. But as Nike technicians studied Amna's movements in the hopes of designing trainers and gloves she could wear to optimize her training, what Amna really wanted was a hijab that was easy to clean and dry and that wouldn't leave her sweaty. Her request led to Nike developing the first-ever sports hijab, a pull-on garment made of power-mesh breathable fabric that rocked the industry when it was launched. It also generated a backlash from those who

"WHEN WE PURSUE UNCONVENTIONAL SPORTS—OR ANY SPORT—FOR THAT MATTER, OTHERS SAY: 'WHAT WILL THEY SAY ABOUT YOU?' IT'S TIME TO CHANGE THE QUESTION AND REDEFINE THE ANSWER: 'HOW MANY WILL YOU INSPIRE?' MANY!"

said the company was cashing in on the oppression of women. Amna shared her perspective on social media, defending the company and the need for athletic hijabs. "When we pursue unconventional sports—or any sport—for that matter, others say: 'What will they say about you?' It's time to change the question and redefine the answer: 'How many will you inspire?' MANY!"

For using her platform to raise awareness about mental health and challenging the misconception that it can be prayed away or trained away, Amna received the Rosalynn Carter Journalism Fellowship for Mental Illness in 2016, making her the first Emirati to win the award. She considers the struggle against depression a lifelong journey but believes that weightlifting is part of her healing, despite the naysayers who say women should stay in the house, not in the gym. "There's a lot of resistance, a lot of rejection. But when that is happening you know you are tapping on something that is untouched, and that's where you start to pave a path for others."

GENERATION M

WEAVING IN AND OUT between partygoers, a chiffon Dolce & Gabbana abaya swishing around her ankles and ice cubes clinking in her J&T—juniper and tonic mocktail—she spots her friends at the bar. Some wear H&M hijabs, others sport halal haute couture from Gucci and Louis Vuitton. They sip nonalcoholic beers and catch up on work, travel plans, and matrimonial apps. Young, Muslim, brand-conscious, and flush with disposable income, this is Generation M, the segment of Muslim millennials who merge faith with modernity and see no need to separate the two.

"Generation M," named by marketing maven Shelina Zahra Janmohamed in her book *Generation M: Young Muslims Changing the World*, is big and lucrative news for global marketing agencies who have dubbed it one of the twenty-first century's most important economic forces. Some agencies are forming offshoots focused entirely on Generation M. Advertising powerhouse Ogilvy launched Ogilvy Noor, of which Janmohamed is vice president, to study the behaviors of millennial Muslims and help brands target their purses: Generation M spends an average of $2.6 trillion a year on Muslim lifestyle products; these include gourmet halal food, adventure travel, halal sex toys, modest haute couture, and nonalcoholic beer.

Unlike their peers of other faiths, the Muslims of Generation M strongly identify with religion. They describe Islam as more than a religion. Islam is a way of life, a distinction that means snacks, morals, and dating habits are guided by faith: everything from how they navigate clothing store changing rooms, pressure restaurants to serve halal food, design their homes, and pick a hair salon.

Generation M is growing. The global Muslim population is projected to grow 73 percent to nearly 3 billion Muslims by 2050, making one in four humans Muslim. Many of them will be young.

At the helm of Generation M are Muslim women with their higher education and employment rates compared to men. Affluent, modern, and faithful, the Muslimahs of Generation M represent a cosmopolitan, devout, and trendsetting future.

MUSLIM WOMEN MAKE HISTORY

BEFORE THE RENAISSANCE, while Europe was still in the Dark Ages, Muslim women were ruling nations, opening universities, executing legal decisions, and solving mathematical equations left unsolved by men. Despite the patriarchy, Muslim women polymaths and polyglots have been blazing trails across the Middle East and North Africa from the time of Islam's inception. While more archival materials exist on these pioneering women's fathers, husbands, and sons than on the women themselves, the rich legacy of Muslim women has persisted through oral storytelling traditions and some written records. Their stamp on history persists through the ornate palaces, schools, and mosques that they erected, as well as the mausoleums where they are enshrined and visited by pilgrims in search of blessings. But don't get it twisted: Muslim women didn't only stick to algebra, law, and calligraphy. Military strategists and warmongers are included in this chapter, representing the breadth of what it means to be a Muslim woman making history, past and present.

MOTHERS OF HIGHER EDUCATION

Fatima and Maryam Al-Fihri, Tunisia

WHEN FATIMA AL-FIHRI and her sister, Maryam, were young girls, their family, along with thousands of others, made the tough migration from their home in the region we now call Tunisia, in search of fortune in the Moroccan city of Fes. In the mid-ninth century CE, Fes was transforming into a booming hub of business and trade, so much so that some even called it "the Athens of Islam." The girls' father, Mohamed al-Fihri, hoped to find financial success as a merchant. The long journey paid off: Mohamed al-Fihri did become a wealthy merchant, so wealthy that when he died unexpectedly, he left his two young daughters bereft, but very rich.

The sisters adored Fes. It was the city that had given them wealth and comfort. They wanted to give back to their community but wondered how to leave a legacy that would continue serving the people of Fes for many years to come. Islam was flourishing in its Golden Age of expansion and scientific discovery, and Fatima was a curious woman, enamored with the scholars and scientists of the time. Her love for learning helped her make the decision: She would spend every penny of her inheritance on the construction of a beautiful university with a huge library. It would take nearly two decades to complete the ornate academic complex that Fatima imagined, and sōme records indicate that she was so dedicated to its completion that she fasted the whole time it was being built. When it finally opened in 859 CE, Fatima named the academic complex the University of al-Karaouine after her family's Tunisian hometown, Kairouan. Next door to the university, Maryam spent her entire inheritance building an Andalusian mosque, a beautiful madrasa for prayer and spiritual study that could hold up to 20,000 worshippers. The entire complex of university, library, and mosque became a symbol of sisterly dedication to higher learning and the generosity of Muslim women.

Scholars from around the world traveled for months to visit the University of al-Karaouine. Astronomers from Egypt, linguists from the Arabian Gulf, and scientists and theologians from Europe assembled in its hallways and lecture halls, sharing insights into the solar system and stars, and teaching one another the newly developed system of

Arabic numerals. Although older academic institutions existed, including India's Taxila and Nalanda universities, Fatima's university is the oldest and longest continuously operating degree-awarding institution in the world. Guinness World Records and UNESCO cite the founding of University of al-Karaouine in 859 CE as a landmark year in higher education. Since Fatima opened its doors in the mid-ninth century, there has never been a period of closure.

Over time, the intricate mosaic tiles and emerald green ceramic roofs of the university were maintained and expanded by wealthy dynasties. During the Almoravid dynasty in the twelfth century, the sisters' legacy was expanded, and Maryam's mosque made even larger by Sultan Ali Ibn Yusuf. The mosque was extended from eighteen aisles to twenty-one aisles, taking up more than 32,300 square feet. When the Almohad dynasty took over in the next century, it added new architectural features and fountains. In the fourteenth century, the Marinid dynasty expanded Fatima's library, adding 20,000 books, manuscripts, and rare documents. A vault with a copper door, four locks, and four key holders was added in the sixteenth century to house the rarest, most precious texts. More recently, in 2012, the world's oldest university was restored to its former glory by another Muslim woman: Canadian Moroccan architect Aziza Chaouni.

Today, Fatima's library houses a collection of 4,000 rare books and ancient manuscripts including a rare ninth-century Qur'an written in Kufic Arabic, a manuscript on Islamic jurisprudence written by philosopher Ibn Rushd (Latinized as "Averroes"), and a tenth-century text on the Prophet Muhammad's life. The legacy of Fatima's university and Maryam's mosque stretches over multiple centuries and many continents. The sisters' mark on history includes the education of Pope Sylvester II, who studied at the university in the tenth century, learned about Arabic numerals, and took the new concept back to Europe. It also includes the education of Ibn Rushd and Maimon, known as Maimonides, the Jewish philosopher famous for his work on Jewish ethics and law. Fatima and Maryam died in the late 800s, two centuries before the University of Bologna in Italy—Europe's oldest university—and Oxford University in England would open their doors. Their acts of generosity seeded knowledge throughout the world and cemented them as mothers of higher education.

PRE-PRE-PRE-PRE-RENAISSANCE WOMAN

Sutayta Al-Mahamali, Iraq

MATHEMATICIAN, JURIST, MUFTI, AND SCHOLAR, Sutayta Al-Mahamali was dubbed a genius by not one but three of the great historians of her era. Born in tenth-century Baghdad, Sutayta excelled in algebra and Islamic jurisprudence. She memorized the Qur'an and issued fatwas, or rulings on Islamic law. Nowadays, she'd be called a Renaissance woman, but Sutayta was born four centuries before the Renaissance took Europe from the Middle Ages to modernity. While Sutayta was solving quadratic equations and executing legal declarations in the Abbasid capital, Europe was still in the Dark Ages.

Sutayta was educated by a group of renowned scholars, including her father, Abu Abdullah al-Hussein, an author and judge, as well as her uncle, who was a scholar of the traditions and sayings of the Prophet Muhammad, known collectively as the hadith. There exist more historical records of these male scholars, as well as Sutayta's son, also a judge, than there are records of Sutayta's brilliance. But we know she diligently built on the legacy of the scientists who came before her, including Muhammad ibn Musa al-Khwarizmi, the Persian scientist whose last name was Latinized to "algorithm." In the century before Sutayta was born, al-Khwarizmi published a book on mathematics called *The Compendious Book on Calculation by Completion and Balancing*, or *Al-kitab al-mukhtasar fi hisab al-jabr wa'l-muqabala* in Arabic. The term "al-jabr" from the title became "algebra," and Sutayta's skills in that science were legendary. Not only did she study her predecessor's work, Sutayta invented new solutions for algebraic problems. Her original contributions to the field were marveled over and cited by mathematicians who followed in her footsteps.

Sutayta became an authority on a particular branch of algebra—the mathematics of inheritance. Known in Arabic as fara'idh, inheritance calculations are deeply important to Muslims. The Prophet Muhammad said, "Learn inheritance and teach it." But not

everyone is up to comprehending the holy mathematics. Sutayta used complex formulae developed by al-Khwarizmi to help families determine which members should inherit what from a late family member's estate. Throughout Baghdad, she was known for merging dazzling mathematical skills with incredible generosity. Respected for her kindness and her genius, Sutayta was the go-to person for bereaved families looking to settle complicated inheritance disputes and anyone seeking legal advice. In her spare time, Sutayta deepened her knowledge of Islamic law so she could issue more fatwas, practice Arabic calligraphy, and solve thorny mathematical equations left unsolved by men.

"IN HER SPARE TIME, SUTAYTA DEEPENED
HER KNOWLEDGE OF
ISLAMIC LAW SO SHE COULD ISSUE
MORE FATWAS, PRACTICE
ARABIC CALLIGRAPHY, AND SOLVE THORNY
MATHEMATICAL EQUATIONS LEFT
UNSOLVED BY MEN."

WHO RUN THE WORLD?

Amina, Nigeria

THE FIRST PERSON to establish a Hausa queendom in northern Nigeria was a Muslim woman named Amina (referred to as Aminatu in some historical texts). Amina was born in Hausaland in northern Nigeria in 1533 CE, the eldest daughter of Queen Bakwa of Turunku. Her father was ruler of Zazzau, also known as the Zaria emirate, one of Hausaland's seven provinces. Amina's family lived during a peaceful time and grew wealthy trading horses and kola nuts and importing metals and cloth. But despite the tranquility, a young Amina decided to follow in her mother's militaristic footsteps, train with her father's cavalry, and become an expert at battle. Amina worked her way up the ranks to become leader of the Zazzau cavalry, honing her skills and earning military accolades along the way.

Her fighting skills came in handy when Amina's brother, who had inherited their father's crown, died in 1576. Amina became Queen Amina of Zaria, a forty-three-year-old ruler with military prowess and unbridled ambition. Within the first few months of her reign, she led an army of twenty thousand soldiers to annex nearby cities and conquer surrounding states. Under her rule, the borders of Hausaland encompassed a greater region than ever before.

Victory came at a cost: Queen Amina's thirty-four-year rule was a period of near-constant warfare. She led her army to take over states including Kano and Katsina, and marched her troops as far north as Nupe, near the border with Niger. She used force to control many trade routes across Hausaland, and everywhere she went, she demanded safe access and movement for Hausa people, expanding the reach of Hausa trading and economy. She was instrumental in designing and constructing thick fortifications around every city she conquered and each military camp she established. Made of earth, these guard walls became known as *ganwar,* or "Amina's walls," and some are still standing in modern-day Zaria, a province in northern Nigeria.

Queen Amina's legacy as a warrior queen and military strategist continues through the *Kano Chronicles*, a written account of Hausa history, as well as oral storytelling. In the center of Lagos, a prominent statue shows a bronze Queen Amina brandishing a spear atop a rearing horse, her face determined and ready to take over the world.

THE NOBLE QUEEN
Arwa al-Sulayhi, Yemen

FIRST SHE RULED the Sulayhid empire with her first husband, then he died. Then she ruled with her second husband, but he also died. By the time Arwa al-Sulayhi was nineteen years old in 1067 CE, the teenager was single-handedly ruling Yemen. Arwa became the region's longest-reigning, and arguably most-loved, leader in history. Her governance for more than five decades was characterized by a dedication to building academic institutions, roads, and agricultural infrastructure and earned her the monikers of Noble Queen, Noble Lady, and Little Queen of Sheba.

Arwa was born into a ruling family in the mid-eleventh century in Jabal Haraz, a mountainous region in Yemen and the stronghold of the Sulayhid dynasty. It was also the center of Isma'ilism in Yemen, a branch of Shi'a Islam that accepts Imam Isma'il ibn Jafar as successor to Imam Ja'far al-Sadiq. Arwa's parents died when she was a young girl, and her aunt, the indomitable Asma bint Shihab (who gained infamy for attending political meetings without a veil), and uncle Ali bin Muhammad, who were rulers of Yemen, adopted Arwa. They educated her in spiritual and poetic practices, including memorization of the Qur'an, in preparation for a life of leadership. But a young Arwa was thrust into that role a lot sooner than anyone had expected. Her aunt and uncle died while she was a teenager, as did her first two husbands. Undeterred, Arwa took on the role of sovereign, making decisions as significant as moving the capital of Yemen from Sana'a to Jibla. She also pushed for the extension of Isma'ilism into regions as far away from Yemen as Gujarat in western India, a legacy that remains today in the form of the Dawoodi Bohra, Alavi, and Sulaymani Isma'ili communities in India.

While she didn't go quite as far as her aunt in turning up to state council meetings without a veil, Arwa still pushed boundaries. Her very presence in rooms filled with politicians meant she was the lone woman, even though she was the most powerful person at the table. Arwa refused to hide behind a screen to conduct her work, a common practice for women of the time. She was one of only two Arab Muslim women at the time to have their names proclaimed during the khutbah, the official Friday sermon that takes

place in a mosque, a practice reserved for only the most special and worthy (and male) followers. In Arwa's case, her proclamation during khutbah was in recognition of her status as a monarch. She was also the first woman in history to earn the title of hujja, a special designation in Isma'ili Islam that signifies a person as having a deeper relationship with God than any other living human. Hujjas are considered the closest living image of God's will and serve as mediators between humans and God.

Historians say Arwa was encouraged to marry a third time in 1091 CE when she was forty-three years old. She did so reluctantly and only because it was necessary for her to stay in power. But then her third husband died and Arwa continued to rule alone, as she preferred.

Arwa was the sovereign of Yemen until her death in 1138. Her mausoleum in the Queen Arwa Mosque, one of the oldest mosques in Yemen, which she ordered to be built out of a palace, is now a place of pilgrimage, visited by thousands of worshippers who pay tribute to the Noble Queen of Yemen.

"HER GOVERNANCE FOR MORE THAN FIVE DECADES WAS CHARACTERIZED BY A DEDICATION TO BUILDING ACADEMIC INSTITUTIONS, ROADS, AND AGRICULTURAL INFRASTRUCTURE AND EARNED HER THE MONIKERS OF NOBLE QUEEN, NOBLE LADY, AND LITTLE QUEEN OF SHEBA."

HALOODIES

MUSLIM FOODIES savor single-estate chocolate beans and gourmet sausages, but stick to what's halal, or "lawful" in Islam, which means avoiding pork, alcohol, blood, and carnivorous animals. Put "halal" and "foodies" together, and you have "haloodies," a burgeoning cohort that is demanding the opportunity to choose a seven-course meal from the entirety of a Michelin-starred restaurant's menu—not just the vegetarian section.

Twenty thousand haloodies gather every year at the Halal Food Festival in London to gorge on global delicacies without worry that the jiggle in their raspberry panna cotta comes courtesy of animal-derived gelatin, or that the flaky crust of a Cornish pasty (a small savory pie) was kneaded with suet or lard. Their demands are being heard. Some of England's fanciest restaurants now serve halal meat, while fast-food chains are increasingly catering to haloodie tastes.

That might not be enough for haloodies. Pushing past the concept of halal, some are asking for food that is tayyab, or "pure," and meets ethical values of sustainability, respect for the environment, and comes from a food-production system based on Islamic ideals of good health and hygiene.

While not every Muslim observes halal or seeks out mocktail-making mix-ologists or tayyab farm-to-fork restaurants, nine out of ten Muslims in the UK eat only halal meat, according to British meat organization Eblex, and American demand for halal food increased 15 percent from 2012 to 2015, according to global data tracker Nielsen. Some non-Muslims are joining the movement, arguing that halal meat tastes fresher and cooks better.

For haloodies, the dream of sharing a playground friend's chewy candies with-out fear of eating gelatin, or grabbing a rotisserie chicken from a grocery store in a non-Muslim country, is about more than sugar highs and convenience. It's about feeling a sense of belonging in places that push us to the margins.

MUSLIM WOMEN EXPERIMENT

STARING PANDEMICS in the face, growing plants in microgravity, and conjuring solutions to mathematics' gnarliest problems, Muslim women are at the forefront of scientific discovery and innovation. Across the Muslim world, women make up at least a third of professionals working in science, technology, engineering, and mathematics (STEM) fields. Despite oppressive, sexist regimes, women account for nearly three-quarters of STEM graduates in Iran, while in Saudi Arabia, Oman, and the United Arab Emirates, around two-thirds of science graduates are women. Dreaming of touching the stars and landing on the moon, our ambition to explore the unexplored takes us to the edges of the known universe and pushes us to confront the limits of our courage and curiosity. Muslim women venture into space, Qur'ans in hand; we twirl in microgravity; and we invent mathematical equations to create our own definitions of success.

ENDING AN EPIDEMIC

Quarraisha Abdool Karim, South Africa

QUARRAISHA ABDOOL KARIM was twenty-one years old when a mysterious disease started to spread through her country. HIV, the virus that causes AIDS, was still nameless in 1981 when it began ravaging families, destroying economies, and confounding doctors and scientists around the world. Within a few years, the virus leapt from the forests of West and Central Africa to every corner of the planet, infecting and killing millions. Quarraisha's native South Africa became the epicenter of the largest and deadliest pandemic humanity had ever witnessed. The virus ripped through the country, leaving behind a nation of AIDS orphans. Almost one in five people infected with HIV lived in South Africa, despite the country being home to less than 1 percent of the global population.

Quarraisha watched in horror as the new epidemic spread from one township to another, from her home in Tongaat, KwaZulu-Natal, on the east coast, all the way to the Western Cape. HIV preyed on the very cells designed to protect the human body from infection. White blood cells, our defense against viruses, bacteria, and fungi, were being taken over by HIV, and people were dying from usually benign bugs, infections a healthy body would fight off with ease, their bodies withering beneath the weight of lung, stomach, and brain infections. Quarraisha noticed how a tiny microbe shone a light on the injustices in society. HIV preyed on the most vulnerable in society, people who were marginalized because of their race, gender, and sexuality. Rates of infection were up to four times higher in Black Africans compared to whites. Among the most vulnerable South Africans were teenage girls and young women aged fifteen to twenty-four, who were eight times more likely to be infected with HIV than their male peers. Sexism and sexual violence heightened their risk of HIV infection.

As HIV spread across the country, South Africa was still under a racist regime that enforced apartheid. By day, Quarraisha was a science student working in a university lab; by night, she fought in the anti-apartheid movement, protesting for racial equity. When HIV emerged, Quarraisha's worlds of science and social justice collided. The new

"BY DAY, QUARRAISHA WAS A SCIENCE STUDENT WORKING IN A UNIVERSITY LAB; BY NIGHT, SHE FOUGHT IN THE ANTI-APARTHEID MOVEMENT, PROTESTING FOR RACIAL EQUITY."

epidemic would define her life's work. She graduated with a bachelor of science from the University of Durban-Westville in 1981, the same year that HIV emerged, then studied for a master's degree in infectious diseases at Columbia University in the United States before returning to South Africa to fight the spread of HIV. If the virus was going to prey on her country's people, then Quarraisha was going to fight back.

In 1994, when fifty years of apartheid was finally ended, Quarraisha established South Africa's first AIDS program. But not everyone was united in the struggle against HIV. The South African president, Thabo Mbeki, was in denial. He argued that HIV did not cause AIDS and that Western leaders were trying to dupe Africans. His refusal to believe the science cost the lives of more than three hundred thousand South Africans. Outraged by the injustice and determined to stop the epidemic, Quarraisha teamed up with her life partner, Salim Abdool Karim, to map the spread of the epidemic across the country. Their findings emphasized the need for activism alongside science. If HIV was going to be tackled, it couldn't be fought in the laboratory alone. Social factors fueled

the spread of the disease, and a real effort to battle poverty and racism was necessary if the epidemic was going to be controlled. Two years after she graduated with a PhD in medicine from the University of Natal, Quarraisha cofounded CAPRISA, the Centre for the AIDS Program of Research in South Africa. The center opened its doors in 2002, and Quarraisha became its Associate Scientific Director, launching the research that would spark a breakthrough and thrust her into the international spotlight.

Quarraisha wanted to help the most vulnerable people in society. If women and girls were most susceptible to HIV, then she would focus her research on developing technologies that women and girls could use to protect themselves from infection. In 2007, she and her partner launched a clinical trial called CAPRISA 004, which aimed to test a new idea: Could the same drugs used to treat HIV be used to prevent infection in the first place?

The breakthrough came in June 2010. Quarraisha and her team proved that women who used a gel laced with anti-HIV medicines topically before and after sex had a 39 percent lower chance of becoming infected with HIV and a lower risk of herpes. The results were celebrated throughout the world. Finally, women who were not able to negotiate condom use could discreetly use a gel and protect their bodies from HIV. Quarraisha's remarkable discovery offered her a platform to shout even more loudly for the rights of women and girls. She was appointed as a UNAIDS Special Ambassador for Adolescents and HIV, and her breakthrough was named one of the Top 10 Scientific Breakthroughs of 2010 by *Science* and earned her the 2016 L'Oréal-UNESCO For Women in Science Award as well as South Africa's highest honor, the Order of Mapungubwe.

As of 2019, South Africa still has the biggest HIV epidemic in the world, with more than seven million people infected and more than three million killed since the epidemic began. Quarraisha continues to track the course of HIV as it spreads through veins and across borders, upending lives and perpetuating vicious cycles of poverty and oppression. In three decades working as an infectious disease epidemiologist and taking up professorships at the University of KwaZulu-Natal and Columbia University, Quarraisha has fought to protect and empower women and girls to live long healthy lives that they control. And while she has made significant progress, she says that until there is a cure for HIV, her work is not over yet.

REACHING FOR THE STARS

Anousheh Ansari, Iran

JETTING INTO SPACE and floating among the stars had been a lifelong dream for Anousheh Ansari, ever since she was a little girl staring at the sky in the mountain town of Mashhad in Iran. People told the little girl that her obsession with rockets was a phase she would grow out of. But in 2006, Anousheh made her wildest dream come true. Six days after her fortieth birthday, she gifted herself the most spectacular birthday present—one with a $20 million price tag. Strapped into a Soyuz rocket, Anousheh burst through the planet's atmosphere and landed 220 miles above earth on the International Space Station, making her the first Muslim woman in space, the first female private space explorer, the first Iranian astronaut, and the first woman to self-fund her trip to space. From her new vantage point orbiting earth, Anousheh reflected on her four decades as an immigrant woman entrepreneur and scientist. There had been many hurdles, but she had just overcome the biggest one. She had made it to the stars, and nothing could hold her back now.

Anousheh was barely a teenager when she witnessed Iran's Islamic Revolution in 1979. The Shah was overthrown, and a new regime assumed power. With the Supreme Leader Grand Ayatollah Ruhollah Khomeini at its helm, the new guard made the veil mandatory for all women, regardless of faith or nationality, banned women from attending university, and fired thousands of professional women from their jobs and ordered them to take on household chores. Decades of activism for women's rights were undone, and war broke out between Iran and Iraq. Five years later, while war was still raging, Anousheh's family fled their home and immigrated to the United States. Anousheh was sixteen years old, a stranger in their new home in Texas, and she couldn't speak a word of English. Her goal of space travel felt even further out of reach, but she kept the dream alive. Anousheh immersed herself in books about engineering and astronomy, quickly became fluent in her new language, and grew even more determined to fly to space.

Tensions between Iran and the United States were high when Anousheh studied for her undergraduate degree in electronics and computer engineering at George Mason University in Virginia. She wondered how an Iranian woman living in America would ever make

it through the bureaucratic hurdles to become an astronaut. But she forged ahead with her plan for a career in engineering and entrepreneurship, pursuing a master's degree in electrical engineering at George Washington University in America's capital, then landing a job at a telecommunications company, MCI, where she met her husband. Anousheh convinced him they should leave and start their own venture. In 1992, they launched Telecom Technologies Inc. and sold it for more than $500 million eight years later. Financial success was unexpected, and it hadn't come easy. As a thirty-year-old CEO, Anousheh saw how men talked over her at board meetings, how her ideas were ignored only to be coopted later by a man who would take the credit. The injustice infuriated her.

But she had forged a path many said could not be forged by a woman. She had founded, run, and sold a multimillion-dollar business. The pushback made her even more determined to achieve her goal of space exploration, which people kept dismissing as a whimsical, laughable dream. Anousheh figured that even if she couldn't go to space herself, she would do everything in her power to support the scientists reaching for the stars. She channeled her money to help rocket-makers take humans into space by funding the Ansari X Prize in 2001, a year after she sold her company. The prize would give $10 million to the first company to make a rocket capable of flying humans into space twice in two weeks. When the winner of that award formed a partnership with the Virgin Galactic Company to make a commercial rocket, Anousheh made sure a seat was saved for her.

But her path to the stars still wasn't clear, and commercial space travel was being stifled by lawmakers who knew little about science and space exploration. Realizing that her dream was far bigger than her, Anousheh funded a bill that began to free the private space industry from some of the bureaucratic hurdles and helped make way for innovations in the technologies that would help amateur astronauts rocket into space. While she was focused on these ventures and starting to think about establishing her second company, her chance at space travel came knocking. The private space exploration company Space Adventures in Virginia offered Anousheh a spot to train alongside other hopeful astronauts. Three men had already made it into space as amateur astronauts. If Anousheh was picked, she'd make history as the first female private space explorer. But there was another challenge: training would take place in Russia *in Russian*. Already fluent in Farsi, French, and English,

Anousheh would have to add another language to her repertoire. Quickly picking up speed, she spent six months in Star City, Russia, undergoing the physical training necessary to pursue her childhood dream. Every day, from 7 a.m. to 7 p.m., Anousheh learned how to board the small Soyuz rocket that would launch her into space. Flight simulations and drills taught her to make repairs if equipment failed or if a crew member became ill.

Six months of space training was not a guarantee for space travel. But years of dreaming and persisting and preparing collided with luck when in September 2006, six days after her fortieth birthday, Anousheh was strapped into a Soyuz rocket in Kazakhstan and launched into space. With both the American flag and the colors of the Iranian flag stuck to her spacesuit, Anousheh broke through barriers people told her she would never penetrate. From the small window of the Soyuz capsule, she looked out at the blue planet spinning beneath her and cried. A childhood dream conjured among the mountains of Mashhad was really happening. From fleeing an oppressive revolution, making a home in a foreign land, and achieving success in industries dominated by men, Anousheh was now floating above the planet. The journey to the International Space Station took two days. Then she spent eight days on the ISS conducting experiments, reading the Qur'an, and writing a blog that was read more than 50 million times.

There is a phenomenon known as "the overview effect," which says that space travel is a transformational experience that can shift a person's perspective on borders, humanity, and justice. Looking at the blue planet from hundreds of miles away, witnessing sixteen sunrises and sixteen sunsets in a day, astronauts come back to Earth fundamentally changed. When Anousheh returned to Earth, she possessed a truly global perspective on the planet's problems. She launched Prodea Systems, a company based in North Texas, which studies the Internet of Things and brings technology and internet access to remote parts of the world. And she launched the Ansari Foundation, a nonprofit that supports women entrepreneurs and fights for the freedom of women and girls around the world.

The trip to space only deepened Anousheh's desire to learn about the universe. She began a master's degree in astronomy and wrote a memoir called *My Dream of Stars: From Daughter of Iran to Space Pioneer*, to encourage women everywhere to never ever give up on dreams, even the ones people say are fleeting or impossible.

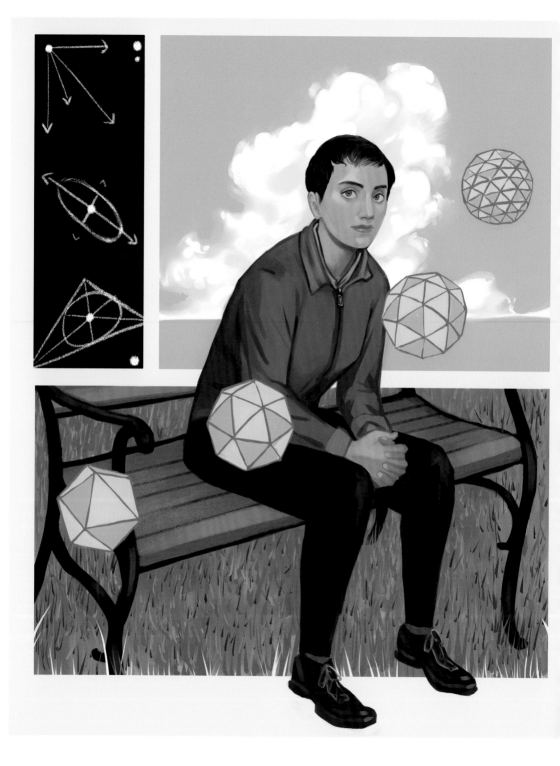

AN INTRICATE PLOT

Maryam Mirzakhani, Iran

THE ONLY WOMAN to win the Fields Medal, the mathematics equivalent of the No-bel Prize, began life in Iran as a girl conjuring stories in her head. An eight-year-old Maryam Mirzakhani would look out of her bedroom window in Tehran and imagine the adventures of a globe-trotting girl who becomes mayor. Writing novels in her head, Maryam dreamt up intricate storylines and characters, a tactic that would serve her well as a mathematician who would imagine complex problems as a series of charac-ters navigating a plot. But Maryam didn't think she would grow up to be one of the world's most respected scientists. Growing up in Tehran through the Iran-Iraq war, she dreamt of becoming a writer.

Maryam's love of science was stoked by her older brother, who regaled his little sister with details of the experiments he had done at school that day, and her easygoing par-ents, who encouraged Maryam to explore all the topics she found interesting, with little pressure to succeed at any one thing in particular. Maryam aced the entrance exams for the Farzanegan middle school for girls where she met her best friend, Roya Beheshti. The pair would walk home together through crowded streets and often stop at a bookstore, where they were prohibited from reading the books and ended up buying them instead. Maryam imagined that she would write a book and share her stories with the world. She was inspired by strong women such as Marie Curie and Helen Keller. Their lives informed Maryam's stories about a globe-trotting girl who would become a leader.

Mathematics didn't seem her strong suit at first. A discouraging teacher in middle school told Maryam that she wasn't very good at math, and Maryam lost interest. But the next year, a more expert teacher brought out Maryam's mathematical talents, and she excelled. One day, Maryam and Roya got their hands on some International Mathemat-ical Olympiad problems, and Maryam solved half of them. Taking them to the principal as evidence that she needed extra classes to solve mathematical problems, the principal made the arrangements, an option only available to boys at that point. "The principal of the school was a very strong character. If we really wanted something, she would make it

happen. Her mindset was very positive and upbeat, that 'you can do it, even though you'll be the first one.' I think that has influenced my life quite a lot," Maryam said in an interview with *Qanta Magazine.* The principal helped Maryam become a girl who traveled the world. In 1994, when Maryam was sixteen years old, she became the first girl ever to join Iran's national team for the International Mathematical Olympiad, an annual championship that pits the best high school students from around the world against each other. Over the course of twelve days, the students tackled six problems so complex that they are not even covered in undergraduate-level mathematics programs. In the 1994 Olympiad in Hong Kong, Maryam scored 41 out of 42 and won the Olympiad's equivalent of a gold medal, making her the first Iranian student to do so. When she competed the next year in Toronto, Canada, she won two gold medals and received a perfect score—the first Iranian ever to hit that achievement.

Maryam began publishing scientific papers while studying for her bachelor's degree at Tehran's Sharif University of Technology. Her precocious success earned her a spot as a graduate student at Harvard University in the United States, where she took seminars with Curtis T. McMullen, the recipient of a Fields Medal, a prestigious prize awarded to mathematicians under forty. The imaginative stories of Maryam's childhood were morphing into complex mathematical conundrums, but they too unfolded in her mind like characters. After attending Professor McMullen's seminars, Maryam would walk into his office and describe how in her mind she held a picture of what was happening in the problem.

Maryam's research brought together ideas from different parts of mathematics including hyperbolic geometry and Riemann surfaces. She even developed a new proof for the Witten-Kontsevich formula, a formula that has perplexed many of the brightest mathematical minds. Harvard awarded her a Merit Fellowship in 2003, and when she graduated with a PhD the next year, it tried to keep her with the offer of a junior fellowship. But Maryam declined; Princeton University had made her a better offer. She became Assistant Professor of Mathematics at Princeton University and over the next few years published a series of three papers that her peers described as thoughtful, deep, and unrushed. In 2008, Stanford University offered a professorship, and Maryam moved across the country with her partner. In 2011, their daughter, Anahita, was born.

Maryam's star continued to rise as she took on harder and harder mathematical problems. A couple of years before moving to Stanford, she had begun a collaboration with mathematicians Alex Eskin and Amir Mohammadi. The trio's work on geodesics, curves representing the shortest path between two points, was revelatory. It was a breakthrough: They showed that certain types of geodesics, known as complex geodesics, were regular rather than fractal. It was this work that would lead Maryam to a podium in Seoul, South Korea, in 2014 where she would collect her own Fields Medal.

Maryam died of breast cancer in 2017 at forty, three years after making history as the first woman and the first Iranian to receive mathematics' most prestigious prize. Her death sent shockwaves around the world. Students and colleagues remember her as generous and innovative, a woman with deep intellectual curiosity, imagination, and a drive to keep searching for answers.

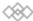

"WRITING NOVELS IN HER
HEAD, MARYAM DREAMT UP INTRICATE
STORYLINES AND CHARACTERS,
A TACTIC THAT WOULD SERVE HER WELL AS
A MATHEMATICIAN WHO WOULD
IMAGINE COMPLEX PROBLEMS AS A SERIES
OF CHARACTERS NAVIGATING A PLOT."

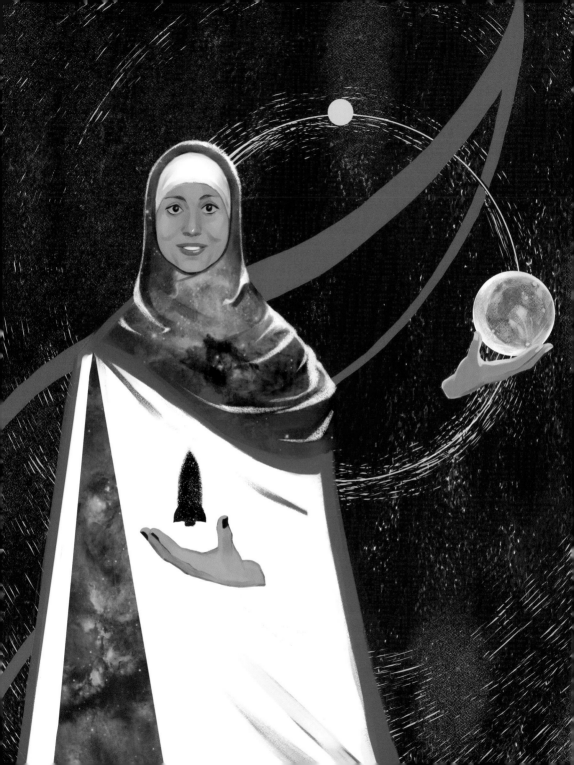

EVERYTHING IS POSSIBLE

Tahani Amer, Egypt

THE LITTLE GIRL loved watching her father fix car engines. Growing up in the suburbs of Cairo, Egypt, Tahani Amer helped as her father took pieces of the engine apart and put them back together. She noticed that she was the only girl lingering by his feet while he worked. The other girls wanted to be teachers and nurses, but Tahani knew she wanted something different—a life of figuring out how things work, of breaking things and fixing them. She dreamt of becoming an engineer.

Determined to become a scientist, Tahani left Cairo to study mechanical engineering in the United States in the early eighties. A young woman in hijab, she couldn't speak more than a few words of English and knew little about life outside of Cairo, and practically nothing about life in Norfolk, Virginia. Norfolk, on America's East Coast, was home to Old Dominion University, where Tahani graduated with a bachelor's degree in mechanical engineering in 1992 and a master's degree in aerospace engineering in 1994. Although she didn't know English, Tahani knew she was smart. She got an A in her first calculus class and knew a life of engineering awaited. It was at Old Dominion that Tahani began her love affair with the National Aeronautics and Space Administration (NASA). When an opportunity arose to work with NASA through the Virginia Space Grant Consortium, Tahani jumped at the chance. She juggled her undergraduate course load with helping NASA's Computational Fluid Dynamics Team. She relished working alongside real-life NASA scientists. The mission to become a researcher there was firmly planted in her mind.

Tahani loved NASA: its lofty mission, the way it reached for the moon even as politicians kept cutting its budget. She knew she wanted a job there. With two degrees in her pocket and a stack of résumés in her hand, Tahani went door to door knocking on the offices of every supervisor in one NASA department. There were a string of nos. Every door closed in her face. But then it happened. Noticing her grit and determination, her academic achievements and her experience, NASA offered Tahani a job in the Aeronautical Research Program. Fresh out of her master's program she began work scaling

"TAHANI CONTINUES TO
CLIMB THE RANKS AT NASA, BUT WHILE HER
SUCCESS REACHES GREATER HEIGHTS,
SHE IS MORE INTERESTED IN BRINGING OTHER
WOMEN ONTO THE LADDER WITH
HER THAN SHE IS IN RACKING UP ACCOLADES
AND ACHIEVING SUCCESS ALONE."

the ceilings of NASA's wind tunnels, the large passages where aircraft are "flown" while still on the ground. Tahani climbed the ceilings of wind tunnels to install probes so she could take measurements as experiments were conducted. In the wind tunnels, industrial machines forced air over and around aircraft while Tahani and her colleagues measured the airflow and aerodynamic forces. "It was great," she said in a NASA video. "I was like a little girl in the candy store of NASA. Everything seemed possible."

Tahani ran experiments to understand the temperature and pressure sensitivity of paint in NASA's wind tunnels. Eventually she began working on the thermal conductivity of thin films, filing a patent for a device that helps scientists take measurements across films. And just when her career trajectory was going up and up, she decided to throw in a challenge—Tahani went back to graduate school. Adding leadership to her list of skills, she began a PhD in engineering management at Old Dominion University, and when she returned to NASA as Dr. Tahani Amer, it was in a management role.

Tahani continues to climb the ranks at NASA, but while her success reaches greater heights, she is more interested in bringing other women onto the ladder with her than she is in racking up accolades and achieving success alone. In 2014, she received NASA's Public Service Award for her work encouraging young people, and especially young women, to pursue careers in science, technology, engineering, and mathematics.

"If you say, 'What's your footstep? What's your legacy?' it is not you defining that. It is the people after you who define that for you," Tahani says in a video about women at NASA. For those following in her footsteps as she scales the ceilings of wind tunnels, climbs the leadership ladder, and pulls other women up to join her, Tahani has created an equation:

$$\textbf{Success = (Passion x Perseverance) + (Network x Time)}$$

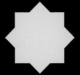

MUSLIM WOMEN MEAN BUSINESS

WITH A FLAIR for innovation and an eye for opportunity, Muslim women are taking note of the corporations and industries excluding us and are cashing in on their myopia. From hot sauce to mascara, real estate to social enterprises, Muslim women entrepreneurs are crushing self-doubt, embracing risk, and converting their passions into profits. Providing services and products to a growing sisterhood that is conscious of sourcing and ethics, these women are blazing trails for the inventors and investors of the future.

STEP INTO THE VOID

Nura Afia, Lebanon

NURA AFIA began watching YouTube videos regularly while breastfeeding her daughter, Laila. It was 2011, Nura was nineteen and recently married, and YouTube was full of makeup tutorials. But Nura noticed a gap in the offerings: The beauty vloggers gaining popularity on the platform didn't look like her and they didn't cater to the needs of women like her—women who enjoyed cosmetics, loved their hijabs, and needed makeup looks that paired well with headscarves. Nura stepped into the void. Borrowing a laptop from her in-laws, she recorded her first YouTube video while her baby was a few months old. Squinting into the camera, Nura swept bronze and chocolate-brown eyeshadows across her eyelids for a smoky-eye tutorial. Flicking her liquid eyeliner into a perfect wing, she offered step-by-step instructions for an expert cat eye. Next, she filmed videos on flawless foundation and contoured cheekbones. Beneath the primer and concealer was the message that makeup was fun and for everyone, despite the lack of diversity in the YouTube landscape. Nura quickly became the personal makeup instructor to thousands of women who saw themselves reflected in the young mother. With each pump of a mascara wand, Nura was saying, yes, we can wear hijab and be beautiful. Yes, we can curl our lashes, rock highlighter on our cheekbones, and rule the world.

Makeup was forbidden to Nura when she was a teenager in Aurora, Colorado. Her mother, Anne, made only one exception—Nura was allowed to smear traditional, powdery kohl across her bottom lash line because she had committed to wearing hijab. Anne was born in Lebanon to a Swiss-Lebanese family and converted to Islam as an adult in the United States, a decision that upset her parents, especially when Nura and her sister started covering their hair. As the girls became young women, their grandmother came around to the idea that hijab and success weren't mutually exclusive. "I think she really felt like I couldn't do anything because I wear a scarf," Nura told Yahoo.com. "She really thinks it holds me back." But secretly, Nura believed hijab would hold her back, too. She and her twin sister were the only girls who wore hijab at Aurora's Smoky Hill High School. There

were no hijabis in the pages of her favorite fashion magazines, no tips on the best way to blend bronzer into cheekbones when wearing a headscarf. There were no Muslim women role models to prove to her that women could both be Muslim and successful.

Once she began making video tutorials, though, it was Nura's commitment to wearing hijab and her steadfastness to her beliefs in the face of pressure to conform that launched her to stardom. Less a hindrance and more a symbol of strength and persistence, Nura's hijab signaled that she was a woman who expressed herself the way she wanted, with silk wraps and bubblegum-pink lip gloss, a woman who didn't conform to other people's demands. Within months of launching her YouTube channel and Instagram page, hundreds of people subscribed. Within a few years, Nura's fan base expanded into the millions. Subscribers told Nura they had felt like outsiders in society because they never saw people who looked like them in the videos they watched before they saw hers. Eyelash curler in hand, Nura showed millions of followers that it was possible to wear hijab *and* be a social media superstar, mother, and entrepreneur.

Awed by Nura's following, fashion companies and makeup brands came calling. Nura shot campaigns with Tarte Cosmetics, Revlon, and Anastasia Beverly Hills, as well as hijab brands who coveted her reach on social media and a piece of the $66 billion-a-year Muslim cosmetics industry. Still, some agencies told Nura she couldn't be booked for jobs because she wore hijab. Others felt that she would not be an appropriate fit for hairstyling endorsements because they incorrectly assumed that women who wear headscarves didn't use hair products, as if hijabis didn't suffer bad hair days. Nura, who liked to dye her brown locks platinum blond, knew this wasn't the case, but it was still difficult to notice the checkout clerk's sideways looks when she approached a store register with curling irons and hairspray in her basket.

At times, the pressure to conform was staggering. Even as Muslims were being recognized as makeup consumers and cosmetics powerhouses like L'Oréal were signing Muslim ambassadors, including British vlogger Amena Khan, some social media stars felt that hijabs hindered success. "I've seen a lot of people take their scarves off being in this beauty community, feeling like they need to change to grow," Nura said in a video. "So I decided to keep wearing my scarf." To Nura, makeup was for everyone, although it held a special place for Muslim women. "Makeup for girls who wear hijab is extra special,

'cause it gives us a chance to play up our face," she said, spritzing her makeup with setting spray in a video for *Elle* magazine.

A four-sentence email in the summer of 2016 changed Nura's life and catapulted her to stardom. CoverGirl, one of the biggest cosmetics companies in America, offered her the opportunity to step into the role of its first Muslim woman brand ambassador. But Nura, thinking the email was a scam, ignored it for days. When she finally responded, she was quickly on a plane to California, glossing her lips beneath the bright lights of a Los Angeles film studio. Nura shot a television commercial for a CoverGirl mascara and posed for a giant billboard that appeared in Times Square. Having made history, Nura is creating her own fashion line, designing edgy and modest clothing for women like her: young, Muslim, fashion conscious, and the face of the future.

"EYELASH CURLER IN HAND,
NURA SHOWED MILLIONS OF FOLLOWERS
THAT IT WAS POSSIBLE TO WEAR
HIJAB *AND* BE A SOCIAL MEDIA SUPERSTAR,
MOTHER, AND ENTREPRENEUR."

TAKE CHARGE

Hawa Hassan, Somalia

ALONE IN SEATTLE, Hawa Hassan ate hot wings from 7-Eleven for dinner. Thousands of miles away from her family and disconnected from her Somali culture, she longed for the fragrant spices of her mother's home-cooked food and the loud mealtimes she shared with her siblings. There were no sambuusas or lahoh on the grocery store shelves of her new town, no Somali restaurants in 1990s Washington state where she could comfortably spoon banana into her mouth with hunks of stewed bariis iskukaris. Hawa hadn't seen her family in fifteen years, not since she was seven years old and left the Kenyan refugee camp in 1993 that had been their shelter from Somalia's civil war. Sponsored visas were hard to come by, so when one slot opened on another family's visa, Hawa's mother put her forward, even though it meant being oceans away from her little girl. Hawa traveled to Seattle to live with a family friend, while her family stayed behind.

In Seattle, Hawa enrolled in school and waited for her family to join her. She progressed to high school, joined the basketball team, and still she continued to wait. They never came. Because sponsored visas for refugees were becoming more scarce, they were forced to settle in Oslo, Norway, instead. Dousing her dinner in hot sauce, Hawa wondered if she would ever be able to afford a ticket to reunite with her mother and ten siblings. Would they even recognize her if they met?

While she was still in high school, a friend's modeling agent suggested Hawa attend some casting calls. Hawa was more focused on basketball, but decided to give modeling a try. Immediately, she was a hit. Jobs with Macy's and Nordstrom gave her enough money to move to New York City, where she hoped to make it big as a supermodel. But New York City agents and bookers had a different idea—there were enough Black women models, as far as they were concerned.

Despondent, Hawa pooled her resources and found she had enough money saved to stop working for a while, and to buy a ticket to Oslo. She would finally get to see her family. The reunion at the Oslo airport was loud, emotional, and familiar, as if Hawa and

"I WANTED TO START A DIFFERENT KIND OF CONVERSATION—A POSITIVE ONE— ABOUT BEING SOMALI. WHAT COULD BE A BETTER WAY TO DO THAT THAN THROUGH FOOD?"

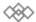

her mother just picked up and carried on the conversation they had left fifteen years earlier. In her family's home, Hawa sat in a circle with her siblings on the floor as the scent of turmeric, cloves, and cardamom wafted around them. It was a special alchemy of food made by her mother's hand, the familiar taste of Somali food's Italian, African, and Indian flavors dancing on her tongue.

Hawa had taken her Vitamix blender with her to Oslo to play with the idea of launching a line of juices. But her mother sniffed at that idea—too many people had already done it. Hawa blended tamarind with dates and coconut with cilantro to make the sauces Somalis add to the sides of their plates every meal, similar to the way Americans use ketchup or hot sauce. If the juice market was saturated, she would launch a range of Somali sauces instead. Basbaas, meaning "chili" in Somali, was born. "It's a family heirloom, but also a Somali thing. Everyone makes it a little bit differently," Hawa said to *Vogue*. Hawa left New York City to live in Oslo for a few months to develop and test the sauces, but it soon became clear that this new venture was about more than food. "I wanted to start a different kind of conversation—a positive one—about being Somali. What could be a better way to do that than through food?" she said.

Starting a business was a team effort. Other businesswomen helped Hawa with her new company, as did her mother, Hawa's source of inspiration. "The level of strength she had to restart so many times gives me so much gratitude for my life. It makes me feel like there isn't much I can't achieve. Sauces were borne out of a deeper desire to connect with my family and to tell different stories about where I come from and to really change the rhetoric on what it means to be Somali, immigrant, refugee, and a woman of color."

Hawa worked with the east Harlem nonprofit Hot Bread Kitchen, a business incubator and social enterprise staffed by low-income women. Her sauces were made at Hot Bread Kitchen until Hawa outgrew the space and needed a larger production facility. In 2015, she moved back to Seattle, her first home in the United States, to launch Basbaas. Quickly, it landed on the shelves of more than twenty Whole Foods stores—the only line of Somali sauces available in the United States.

Sharing food is a way to build bridges, a way to build longer tables and shorter fences so that people can break bread, dip it in sauce, and learn each other's cultures. Hawa uses food to bring people together, even hosting pop-up dinners to encourage conversations about social justice issues such as mass incarceration and immigration. It's been a long, and sometimes lonely, path from refugee to female founder and CEO, and Hawa rejoices in her ability to share her culture through sauces and to determine her daily schedule and life's work. "When I was modeling, I was not in charge of the narrative," she said. But now, she is "every day in charge."

BURST THROUGH BOUNDARIES

Nadiya Hussain, England

WHEN NADIYA HUSSAIN won *The Great British Baking Show* in 2015, 14.5 million television viewers watched her make a promise. "I'm never going to put boundaries on myself ever again," she said. Four years later, Nadiya had written two novels, three cookbooks, three children's books, and appeared on three more television shows, including one called *The Chronicles of Nadiya*. Staying true to her promise, she burst through the boundaries and expectations placed on a British-born Bangladeshi woman who wears hijab.

Nadiya's love of baking began as a coping mechanism for severe panic attacks. Her anxiety disorder was sometimes crippling and made it hard for her to take her children out in public. But in her kitchen, calibrating scales and parsing through recipes, the slow rise of a sponge cake eased her worries. It was anxiety that stopped her from applying to *The Great British Baking Show* in 2013 even though her husband encouraged her to enter. She lacked confidence, Nadiya said, when he kept bringing it up. *But what's the worst that could happen?* he countered. When a new batch of contestants was sought in 2015, Nadiya's husband completed an application for her.

Through rounds of technical challenges and complex bakes, Nadiya built kinship with millions of viewers who saw bits of themselves in the down-to-earth housewife who excelled at translating her feelings into cooking. For the emotional final, Nadiya baked the wedding cake she never had when she herself wed ten years earlier. Clad in her own wedding jewels and a sari reflecting the colors of the Union Jack, Nadiya's lemon drizzle–flavored victory became a national event. It even caught the eye of the Queen, who commissioned Nadiya to make the cake for her ninetieth birthday. "It's mad, because I'm just this five-foot-one Muslim brown girl with three kids, who kind of had a life before all of this," Nadiya told the British press.

She started wearing hijab at age fourteen, a decision that caused bemusement in her household since her parents didn't expect their daughter to observe Islam in a strict way. There was the expectation to have an arranged marriage though, a tradition that Nadiya

"I REALIZE THE IMPORTANCE OF BEING OUT THERE NOW, BECAUSE GROWING UP I DIDN'T SEE GIRLS LIKE ME ON TELEVISION. I DIDN'T SEE BROWN SKIN. I DIDN'T SEE PEOPLE FROM ETHNIC MINORITIES," SHE TOLD *THE GUARDIAN*. "I DIDN'T SEE GIRLS WITH HEADSCARVES."

observed when she got married in Bangladesh—minus a wedding cake—to a man she said she fell in love with *after* they had two children.

Baking wasn't Nadiya's only passion. Writing was also a way of alleviating anxiety and a practice she had begun many years earlier. "I've been writing even longer than I've been baking," she said. A poetry competition that she won when she was seven inspired her to keep telling stories. "Once you reap the benefits of using your imagination, it's a bug," she said. Cookbooks, novels, and children's stories have become avenues for Nadiya to describe the world as she sees it, a world that wasn't reflected in the books at her local library in Luton or on television shows. As a child, Nadiya created characters who could achieve things she never felt she could. She once wrote the story of a superhero who achieved an incredible feat: attending university. "I realize the importance of being out there now, because growing up I didn't see girls like me on television. I didn't see brown skin. I didn't see people from ethnic minorities," she told *The Guardian*. "I didn't see girls with headscarves."

Even the usually poker-faced judge Mary Berry cried when Nadiya was crowned winner of *The Great British Baking Show*. The once modest and unassuming home baker found her voice in her craft: "I'm never gonna say I can't do it," Nadiya said. "I'm never gonna say 'maybe.' I'm never gonna say 'I don't think I can.' I can and I will."

MAR 2 4 2023

DESTROY STEREOTYPES

Halima Aden, Kenya

IN AN ELECTRIC-BLUE burkini and a multicolored hijab, Halima Aden frolicked and smiled in the warm, still waters of the Indian Ocean at Watamu Beach on Kenya's coast. She was born a thousand miles away in a refugee camp in Kakuma, on the opposite side of the country, twenty-one years earlier. Now she was making history, beaming a wide smile and arching her back, a crew of photographers capturing her angles while a flurry of wardrobe assistants readied canary yellow, fuchsia, and emerald green burkinis for her next looks. Refugee, child of civil war survivors, UNICEF ambassador, and now model, Halima was making waves as the first Muslim woman to wear a hijab and burkini for the coveted *Sports Illustrated* annual Swimsuit Issue. It was a feat she had never imagined.

Landing on the pages of *Sports Illustrated* wasn't Halima's first time making history. In 2018, she wore a hijab on the cover of British *Vogue*, the first time in the magazine's 102-year history. The year before, she was the first woman to wear hijab on the cover of a major American magazine: Halima sported a black hijab beneath a red hood on *Allure*'s cover beside the caption "Muslim. Model. Destroyer of Stereotypes." She had been making moves since 2016 when she was elected homecoming queen of her Minnesota high school, the first Muslim ever to hold the title. And just a few months later, she wowed the crowd at the Miss Minnesota USA pageant in a hijab and burkini, the first fully covered Muslim woman ever to compete for the crown. Crown is how Halima describes her hijab. "My hijab—I say this all the time—but it really is my crown and it's something that I bring to the table, something that makes me unique, I feel like it shows the world who I truly am," she told the BBC. On the catwalk or in the grocery store, Halima's hijab is part of everyday life.

Life, before it involved proms and homecomings, was learning to braid hair and singing songs with Sudanese, Ethiopian, and Somali girls in the Kakuma Refugee Camp in northwestern Kenya. Turkana girls from neighboring regions visited to sell camel milk, and Halima's mother would buy some to share with her family using the money she made selling tomatoes and incense. Every month for years, Halima's family waited to hear their name called on the list of refugees chosen for resettlement in another country, a chance

to raise their kids in an actual house instead of a hut made of mud. Chances were slim; Halima's family shared the refugee camp with almost 200,000 survivors of war. But in 2004, it finally happened: The Adens were flown to St. Louis, Missouri, where they lived for a year, before relocating to St. Cloud, Minnesota. When she was eight, Halima chose to wear hijab to emulate her mother Rukia's strength and beauty.

The refugee camp where she was born had been Halima's safe place. St. Louis, Missouri, in contrast, felt far from peaceful. Halima would fall asleep to the sounds of fighting on the streets and wake up to gunshots. At school, Halima's teachers thought the new girl was shy, but Halima didn't speak English and couldn't understand the lessons. She picked up the language quickly, despite the school's lack of English-as-a-second-language classes, but not before there were a few mix-ups between pasta sauce and soap, and shampoo with laundry detergent.

Halima didn't grow up feeling beautiful. Although dark skin was adored in her family, she saw shelves filled with skin-bleaching creams marketed to dark-skinned women. At school, a teacher asked her to draw her favorite Disney princess, and realizing there were none that looked like her made her question her worth and beauty. Watching TV and flicking through magazines, Halima noticed that girls like her were missing from those spaces, too. On the rare occasion Black girls, Muslims, or refugees were mentioned in the news, it was invariably tied to something negative. That became her motivation for modeling. Even election to homecoming queen revealed how significant her achievement was to other Black girls and girls in hijab. "I saw how even something as small as that brought my community and my school together, how it encouraged other girls like me to join student government and clubs," she told *Vogue*. She remembers the girls in hijab approaching her to say "Oh, I want to go to prom" and "How do I get into orchestra?" Halima says it was something she had "no idea about, but they were still coming to me for advice."

A young Halima was warned by her mother not to wear makeup, and encouraged to sport her natural beauty, but Halima went against that advice and began to experiment with lipstick in her early teens. A decade later, she is powdered and painted by the top makeup artists in the world as she poses in the ocean for a groundbreaking photo shoot, encouraging Muslim women to rock the clothes they want to wear—burkinis or bikinis—destroy every stereotype, and live our best lives.

GRATITUDE

NO ONE WILL READ IT. *Who is it for? But there's already a book about Muslim women. Why are you writing this?* When we were first dreaming up this project, it seemed like a book about Muslim women wasn't commercial enough, safe enough, interesting enough for any publisher to say yes. *Put Malala Yousafzai in it,* one publisher said, *you need to include Muslim women people have actually heard of. No, no, take Malala out,* said another publisher. *She's overexposed.* The nos kept coming.

But I am blessed to work with a woman who doesn't stop at nos, a woman who keeps on pushing. When I was convinced this dream of a project had no place in the world, this woman finessed a Hail Maryam pass, found not one, but multiple, publishers who understood our vision, and here we are, holding the stories we dared to tell, the stories we needed to tell. That woman is superstar literary agent Lilly Ghahremani, also known as SuperLilly.

Because of Lilly, the book that almost didn't happen did happen. SuperLilly guided myself and Fahmida through disappointment, excitement, more disappointment, and then amazement. Lilly led us to Cristina Garces at HarperCollins who said: "A book about Muslim women? HELL. YES."

Cristina's yes led us to Najeebah Al-Ghadban, who designed this book, and Soyolmaa Lkhagvadorj. To Lilly, Cristina, Najeebah, and Soyolmaa; Stefanie at Full Circle Literary, and to the entire team at Harper Design, thank you for cheering us on with enthusiasm and helping to create a gorgeous book that beautifully celebrates Muslim women.

Writing books requires snacks and community and comfort. Thank you to the Ruby, a community for women of letters in San Francisco, where I received all three in abundance. This book was also written in a hundred-year-old mansion in Palo Alto, former home of an early-1900s Chaucer professor at Stanford, and my home for more than a year. It felt so right writing in that house, surrounded by redwoods, in a space generously and lovingly curated by Elisabeth Rubinfien and her family. Toda raba to all the Rubinfiens.

Deep abiding gratitude to Dr. Jonathan Berek for creating my dream job and recruiting me to Stanford so that I didn't have to be an unemployed and broke Muslim woman writer. Thank you, Christopher Wynn, reader of the tweet that sparked the prose poem that was published in the *Dallas Morning News*, which gave birth to the book that you are holding in your hands. It's been a journey.

To Zeba, Jennifer, JulieAnn, Mago, Soo, Lisa, Barbara, and Xin, thank you for the pep talks, tarot cards, essential oils, and for being there at 11 p.m. PST with *You've got this* and *We're rooting for you!* texts. Every woman needs a support system like ours. Who knew the biggest gift of the JSK fellowship would be you?

To Fahmida, my partner-in-art: I may be a writer but I still get stumped when describing you and your talent. Thank you for riding these waves with me! I can't wait to rule the world with you.

And to you, dear reader, thank you for spending time with this book, reveling in our stories, and sharing them.

ABOUT THE AUTHORS

SEEMA YASMIN is a Muslim woman who does everything. A medical doctor, poet, author, professor, and journalist, she teaches science journalism at Stanford University, where she is the director of the Stanford Center for Health Communication. Yasmin trained in medicine at the University of Cambridge and in journalism at the University of Toronto. She is a Kundiman Fiction Fellow and is working on her first novel. She was born in Warwickshire, raised in Hackney, and lives in California with her pit bull, Lily.

FAHMIDA AZIM is an illustrator, author, older sister, tea drinker, night owl, and not a doctor. Most days she's hustling for Seattle rent armed with a Wacom stylus and what experts call "moxie." Her work is an exploration in identity and autonomy. She's been spotted on NPR and in publications such as the *New York Times*, *Vice*, and the *Intercept*.